The Campus History Series

CITY COLLEGE OF
SAN FRANCISCO

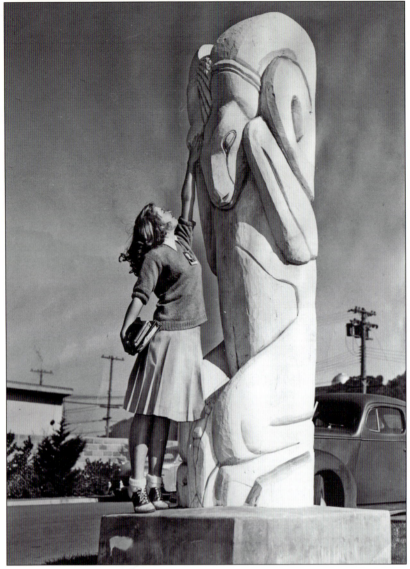

Sophomore Nancy Wallace rubs the forehead of this stylized Ram for good luck before a test in 1948. Located at that time on the college's West Campus, the Ram, originally created of unpainted redwood by Dudley Carter at the Golden Gate International Exposition at Treasure Island, appears here covered in white paint. (San Francisco Public Library.)

ON THE COVER: Visible from Phelan Avenue, Science Hall is pictured here in the early 1950s.

The Campus History Series

CITY COLLEGE OF SAN FRANCISCO

JULIA BERGMAN, VALERIE SHERER MATHES, AND AUSTIN WHITE

9/24/10

For Pat,

Julia Bergman

Valerie L. Mathes

Austin White

ARCADIA
PUBLISHING

Published by Arcadia Publishing
Charleston SC, Chicago IL, Portsmouth NH, San Francisco CA

Printed in the United States of America

Library of Congress Catalog Card Number: 2010926868

For all general information contact Arcadia Publishing at:
Telephone 843-853-2070
Fax 843-853-0044
E-mail sales@arcadiapublishing.com
For customer service and orders:
Toll-Free 1-888-313-2665

Visit us on the Internet at www.arcadiapublishing.com

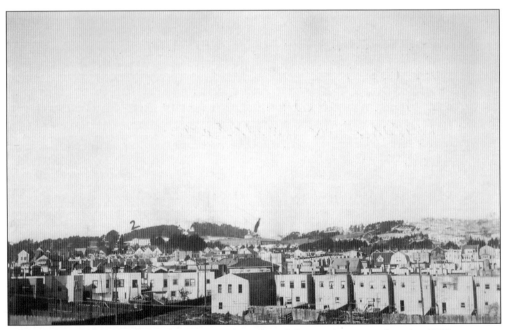

In this panoramic view from Alemany Boulevard and Ocean Avenue, taken in 1929, one can see the country jail for men, near the present location of Batmale Hall, as number one, and the former San Francisco Industrial School, later the women's jail, as number two, where the current college library stands. (Bancroft Library.)

CONTENTS

FOREWORD

It has been an honor to serve City College of San Francisco for over 40 years in my capacity as a teacher and an administrator. City College has provided access and opportunity to over 100,000 students annually in recent years. It has been both inspiring and humbling to witness the multitude of diverse people who have been able to fulfill and advance their academic goals, aspirations, talents, and skills toward gaining meaningful employment, as well as embracing lifelong learning opportunities.

This book starts with a short history of the college's beginnings at many locations throughout the city while looking for a permanent home. Architect Timothy Pflueger designed Science Hall, which was the first building on the Ocean Campus and a welcoming beacon of education visible for miles. I am pleased to share with you that we have kept our promise to serve the neighborhoods of San Francisco by continuing to provide new and expanded facilities. We are one college at many campuses.

I want to especially thank the voters of San Francisco who have generously supported the college through many bond and tax measures for the past 75 years. This support has been crucial to course offerings, college services, and facilities so necessary for student success.

Come to City College, where you will receive a truly multifaceted education; and join us in our Diamond Jubilee year. May the next 75 years be even more brilliant!

—Dr. Don Q. Griffin
Chancellor

ACKNOWLEDGMENTS

Before his untimely death in 2008, Austin White, former chair of the Social Sciences Department, had been working on a history of City College. In his memory and to celebrate the college's 75th birthday in the fall of 2010, Julia Bergman and Valerie Sherer Mathes have undertaken the task of bringing together White's research and historical photographs from many collections.

Although this book is the work of many current and retired members of the college community, the authors especially want to thank Christopher Kox, Mark Albright, Donald Beilke, Madeline Mueller, Darlene Alioto, Sunny Clark, Susan Jackson, and Donald Newton.

Unless otherwise noted, all in-house photographs are from the college archives; the college newspaper, *The Guardsman*; or the college newsletter, *City Currents*, with many by Monica Davey (Davey). Other photographers are credited individually. Additional photographs are courtesy of the San Francisco History Center, San Francisco Public Library (SFPL), and the Bancroft Library at the University of California, Berkeley (Bancroft). The most recent images were taken by Stephen Herman (Herman) and Holgar Hugh Menendez (Menendez).

INTRODUCTION

The Ocean/Phelan Avenue site, former home to a school for juvenile delinquents and later a jail, was the educational dream of Archibald Jeter Cloud, founder and first president of San Francisco Junior College. It would be the only California public junior college committed to an equal emphasis on vocational and traditional academic transfer programs. Established by a Board of Education of the San Francisco Unified School District resolution on February 15, 1935, the college was officially opened on August 26, 1935, with ceremonies held at the War Memorial Opera House. At that time, Cloud challenged the students: "The place which this institution will occupy in the life of the community is dependent upon you as well as upon the faculty; so I would not have you ask this morning what can the junior college do for me, but, rather, what may I do for the junior college?" By 1946, an article in *Look Magazine* placed City College of San Francisco (CCSF) among the first 10 of the best educational institutions in America, and its name appeared in the *Encyclopedia Britannica Yearbook* of 1950. In 1954, its scholastic rating was first in the state and 11th nationally.

Instruction began on September 4, 1935, with morning classes held at the University of California Extension Division building on Powell Street and afternoon classes at Galileo High School, with students shuttling between these widely separated locations, hence the name "Trolley Car College." In addition, students coming in from the East Bay had to add a ferryboat ride. The growth of the student population soon required classroom space at Lick-Wilmerding, Samuel Gompers Trade School, Marina Junior High School, and other locations. Physical education classes were scattered across the city from the Yacht Harbor to Fort Mason to Funston Field. Thus, in a real sense, the history of the college is a history of San Francisco and its transportation system. In 1937, using Maxine Callaway's class schedule, a *San Francisco Chronicle* article detailed the difficulties that students faced. Callaway left her home at 6:40 a.m. to reach the Girls' High School for her zoology lab course. Then she had 10 minutes to get to her history class at 540 Powell Street, which was impossible, so she was always late. She then rushed to her physical education class at Funston Field, where she played hockey, then off to Galileo High School for yet another course and finally to her art class in the rear of Howell's Book Store. The opening of a permanent campus in 1940 finally ended this less than ideal schedule.

To ensure the success of the new college, highly competent individuals were hired. In addition to Cloud, three men and three women comprised the first administrative staff: Eugenie A. Leonard, Ph.D., vice president and dean of women; J. Paul Mohr, registrar; Paul M. Pitman, assistant to the president; Edwin C. Browne, assistant dean of men; Edith E. Pence, assistant dean of women; and Mary Jane Learnard, assistant registrar. In the University of California Extension Building, a cubbyhole, originally designed for checking visitors' hats, served as the central office while Cloud's office at Galileo High School was only slightly larger—8 by 12 feet. Sixty-five faculty members, many educated at prestigious institutions, taught that first semester. The vast majority had a master's degree, two had law degrees, and 18 held either a Ph.D. or an Ed.D, four of them women. Faculty had no office space anywhere. The women's washroom in the basement of the extension building served as the daily sign-in room for all faculty. The 1,483-member student body was recruited by Cloud through a vigorous publicity campaign. All graduating high school seniors in the city were informed by mail in February 1935. So, too, were students living in the East Bay, whose counties did not yet have a junior college. And like the faculty, the students had

nowhere to congregate. In the basement of the extension building, the one study hall could accommodate only one-third of the student body. The college clearly needed a unified campus. Of 22 possible locations, Balboa Park was selected.

However, CCSF was not the first educational institution at this site. Because of increased juvenile crimes during the 1850s, a grand jury had recommended the establishment of a facility to rescue the city's deserted and vagrant children. Therefore, the California State Legislature enacted legislation on April 15, 1858, to establish the San Francisco Industrial School (known as the "House of Refuge") for the "detention, management, reformation, education and maintenance of all children less than eighteen years of age, leading an idle and immoral life." The Industrial School's student population was quite diverse. In their annual report of 1867, out of a total enrollment of 438, there were 110 from foreign countries, 39 were from China, 29 from Australia, and 17 from England. The college that followed was equally as diverse. Between 1935 and 1940, one-third of the students were female, and there were sufficient numbers of African American, Chinese, Japanese, and Filipino students to enable the latter three groups to establish continually active student association clubs. Of the three, the Filipino Students Association was the first organized.

In the mid-1870s, the San Francisco County Sheriff's office constructed a House of Correction near the Industrial School, with only a fence for separation. For decades, the two institutions stood nearby with armed guards watching over the prison population. Because pairs of prisoners were housed in small cells, 6 by 4.5 feet wide and 6.5 feet high, the school facilities were often used for hardened criminals, diluting the Industrial School's original educational mission. The school was closed in 1891, and the prison closed in 1934, thus making way for the beginning of CCSF.

The permanent campus at Ocean and Phelan Avenues officially opened in the fall of 1940 with the completion of Science Hall, designed by Timothy Pflueger. The son of working-class German immigrants, Pflueger began his career as an architectural draftsman. However, by the time he was hired by Cloud, Pflueger had designed the Portola Valley Church (Our Lady of the Wayside), the Castro, Alhambra, and El Rey theaters, the Paramount Theatre in Oakland, and three well-known buildings in downtown San Francisco: the Pacific Telephone and Telegraph Company Building, the medical and dental building on Sutter Street, and the Pacific Coast Stock Exchange at Bush and Sansome Streets. He also served as chair of the board of consulting architects for the Bay Bridge. Pflueger, interested in incorporating art into his buildings, had served as president of the Board of the San Francisco Art Association, was a founder of the San Francisco Museum of Modern Art, and was one of the architects who designed the 1939–1940 Golden Gate International Exposition at Treasure Island.

During the second year of the fair, when European nations had removed their old masters paintings because of the outbreak of World War II, Pflueger created the "Art in Action" program to fill the immense Pan Am Clipper hangar with prominent sculptors, weavers, ceramicists, and other artists in residence. Those who participated included Diego Rivera, Frederick Olmsted, Dudley Carter, and Herman Volz. Funding came from various sources including the New Deal's Work Projects Administration. The most important artwork from the exposition was the Diego Rivera mural, the *Marriage of the Artistic Expression of the North and of the South on this Continent*, or simply *Pan American Unity,* which in 1960 was installed in the lobby of CCSF's Little Theater, now the Diego Rivera Theater. Works by Olmsted, Carter, and Volz also grace the campus as part of its permanent art collection. Pflueger once remarked that the world of art in San Francisco was a triangle, with one point at the San Francisco Art Institute, another at Treasure Island, and the third at City College.

During World War II, all college departments participated in the war effort. The horticulture staff grew plants for military camouflage and, under the slogan "Raise Vegetables for Victory," started the first West Coast Victory Garden program in April 1942, on campus and at a 7-acre site at Laguna Honda. The first campus garden plot was in the area where the former county jail's vegetable gardens had been located. Earlier, Work Projects Administration workers used the same

site to raise plants for the San Francisco Park Commission. By the spring of 1948, victory gardens became freedom gardens. The Mathematics Department offered classes in aviation math, the Engineering Department taught classes in drafting for shipyard workers, and in April 1943, an agreement was reached with the War Shipping Administration to utilize the Hotel and Restaurant Department's staff for training merchant marine cooks, bakers, and stewards. A class graduated every Friday, receiving seagoing assignments. All food produced was sold in the college cafeteria. The Physical Education Department faculty emphasized physical fitness as a wartime obligation, requiring four hours each week rather than the normal two. The Home Economics Department taught classes in the proper method of preserving fruits and vegetables. Other students learned to repair radios for the Army Signal Corps, read Morse code and blueprints, recognize various aircraft, and serve as air raid wardens. Also for the first time, the college welcomed part-time students and, for their benefit, offered extensive day, evening, and summer classes. Even young women participated in "waving parties." For six months after the war ended, some 60 women met at 6:50 a.m. at the foot of Hyde Street, boarded a yacht and, with bright scarves and sunny smiles, greeted every troopship returning from the South Pacific.

The war years also resulted in fewer academic transfer classes and an increase in skill-oriented courses. Because of blackout requirements, no classes were offered on campus beyond 3:30 p.m. Instead, evening programs were offered at Everett Junior High School, because that site was not located on a highly visible hill as was Science Hall, the main classroom building. All intercollegiate sports activities for men were suspended in 1942 for three years. Instead, football, basketball, and baseball games were played with local high school and military base teams. The intramural sports activities of the Women's Athletic Association, however, remained in full and successful operation. The college rifle team, which from the fall of 1935 had won numerous awards, was a permanent casualty of the war. Its rifle range in Science Hall was converted into a student lounge in 1945. All college dances were relocated to less visible locations, often with jukeboxes instead of live bands. One-third of the full-time faculty members enlisted, as did many of the students, leading to a shift in ratio of males to females from 2 to 1 in 1935 to 1 to 3 in the fall of 1943. Beginning in the fall of 1946, the college turned the U.S. Navy's former temporary Women Accepted for Volunteer Emergency Service (WAVES) instructional facility into the West Campus with classrooms, laboratories, offices, and housing for married veterans. The facility's 1,000-seat auditorium and spacious cafeteria were immediately put to use. The college also provided low-cost, on-campus housing for veterans in Hurley Village on 18 acres purchased from the Park Commission in 1946. The following year, additional housing units were made available. By May 1948, Hurley Village was home to more than 550 people, including some 75 children.

With the rapidly emerging economic prosperity following the end of the war, more students attended college. To meet their needs, Louis G. Conlan, who replaced the retiring Archibald Cloud as president, was forced to modify the original integrated building plan for the college designed by Timothy Pflueger. He believed Pflueger's plan could in no way satisfy current, as well as future, enrollment needs of the college. Conlan made it clear that, for economic reasons, none of the buildings on the main campus would ever be a duplicate architecturally of any other. Therefore, the buildings constructed during his presidency, beginning with Cloud Hall in 1954, are all architecturally different. Then in 1962 when the "Baby Boomer Generation" began graduating from high school, CCSF's enrollment rose dramatically. In the fall of 1962, there were 8,400 enrolled. By the spring of 1971, student population had more than doubled to 17,763. Despite campus construction, temporary classroom bungalows had to be brought in, and by 1970 there were 40 such buildings.

In compliance with a state law, the college separated from the San Francisco Unified School District on July 1, 1970, and became the San Francisco Community College District. Under the leadership of the new chancellor, Louis F. Batmale, the district began a bold original educational program to bring relevant credit and non-credit classes to adults throughout the city's various neighborhoods. Batmale once described a community college center as a "unique post-secondary school for adults, which features open enrollment, short term training, no tuition charges, no

advance registration, availability of classes for credit, and year-round instruction offered days, nights, and Saturdays." When he retired on June 30, 1977, the San Francisco Community College District had a total of 61,298 students enrolled: 25,349 at the Ocean Campus and 35,949 at what were then known as the centers, now called campuses.

During the next two decades, the administration, faculty, and staff continued to improve and expand the college's academic programs and its services to the community. In response to the changing needs of those living and working in San Francisco, innovative courses, programs, and services were added at all the campuses throughout the city, continuing the college's long-established commitment to offer educational opportunities to San Franciscans from all walks of life. Then in 1998, Dr. Philip R. Day Jr. became chancellor and, under his inspirational leadership, the college created new programs such as stem cell research and new modes of delivery such as distance learning classes. His tireless support during two bond campaigns resulted in funding for the repair of existing buildings and the construction of new facilities. A new Mission Campus, a Community Health and Wellness Center, and a Student Health Center were constructed during his tenure. Three major projects, the Multi Use Building, the Performing Arts Center, and a new Chinatown Campus will be completed under the leadership of the current chancellor, Dr. Don Q. Griffin.

One

AN INDUSTRIAL SCHOOL, A JAIL, AND CITY COLLEGE OF SAN FRANCISCO

FIRST

ANNUAL REPORT

OF THE

BOARD OF MANAGERS,

OF THE

𝕴𝖓𝖉𝖚𝖘𝖙𝖗𝖎𝖆𝖑 𝕾𝖈𝖍𝖔𝖔𝖑 𝕯𝖊𝖕𝖆𝖗𝖙𝖒𝖊𝖓𝖙

OF THE CITY AND COUNTY OF SAN FRANCISCO.

INAUGURAL ADDRESS

By J. B. CROCKETT, Esq.

By-Laws for the Government of the School, List of Officers, &c.

SAN FRANCISCO:
TOWNE & BACON, PRINTERS, EXCELSIOR BOOK AND JOB OFFICE,
No. 125 Clay Street, corner of Sansome.
1859.

Increased juvenile crime in the 1850s prompted a grand jury's recommendation for a facility to rescue the city's vagrant children who led idle and immoral lives. In 1858, the state legislature passed a law establishing the San Francisco Industrial School. Children were committed either by a parent, a police judge, or the court. The cover of the first annual report is pictured right. (SFPL.)

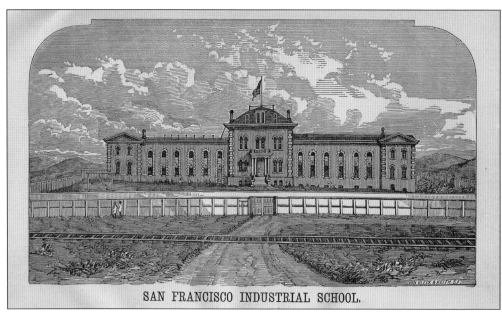

SAN FRANCISCO INDUSTRIAL SCHOOL.

Located on a southern slope, across from the railroad tracks, the Industrial School, above, opened in the summer of 1859. The building initially consisted of one two-story wing and a three-story central structure of brick and wood; a second two-story wing was added on the north in 1865, as seen in this drawing. The entire structure was then finished off in the Victorian style of the times. Students spent six hours a day in the classroom and four to five hours earning their keep, either milking cows at the school's farm or making clothing and shoes. The school was closed in 1891, and children were transferred to the state reformatory in Whittier, and the building, land, and farming capabilities were turned over to the San Francisco County Sheriff as a facility for wayward women. The photograph below shows the structure with only one wing, the other having been destroyed in the 1906 earthquake, forcing female prisoners to be housed in tents. This damaged portion of the school continued to be used as the House of Correction Number Three. (SFPL.)

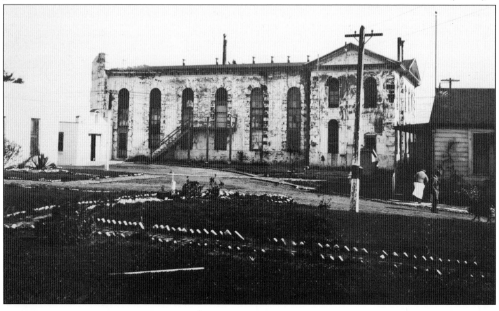

The House of Correction was constructed primarily of wood in the mid-1870s near the Industrial School by the sheriff's office to house male criminals that were awaiting trial but were still considered capable of reform. Collectively, these two buildings were known as the Ingleside Jail, after the adjacent neighborhood. The possibility of fire and the fear of escapes forced the transfer of all inmates to the county jail in San Bruno in 1934. (SFPL.)

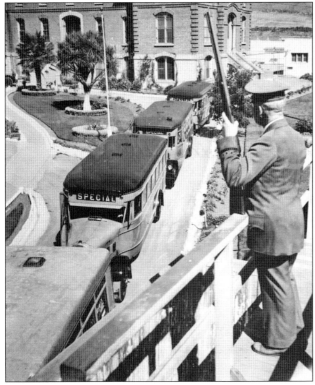

Guard T. A. Bell watches as buses move the last of the prisoners from the House of Correction to their new quarters in the San Bruno County Jail. (SFPL.)

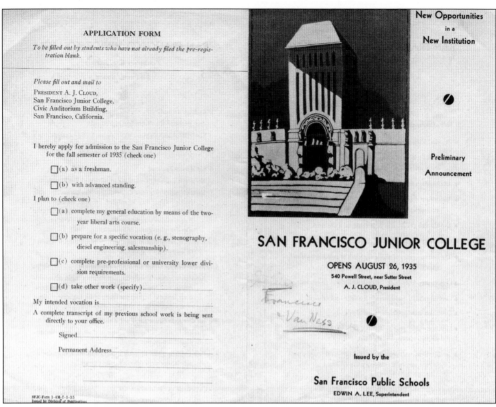

Unlike other state junior colleges, CCSF's curriculum was not devoted exclusively for students transferring to four-year universities. Instead, students could also enroll in preprofessional or vocational programs as seen in the preliminary announcement both above and below. Vocational programs eventually included the Hotel and Restaurant Program, now the Culinary Arts and Hospitality Management Program (spring 1936); a program in the Floriculture (horticulture) Department, now the Environmental Horticulture/Retail Floristy Department (fall 1937); the Police Program (fall 1939); the Civilian Flight Training Program and a Municipal Services Program to prepare students for Civil Service exams (both, fall 1939); and the Fire Program (spring 1940). Also degrees could be obtained in business, lithography, photography, advertising, commercial art, and engineering.

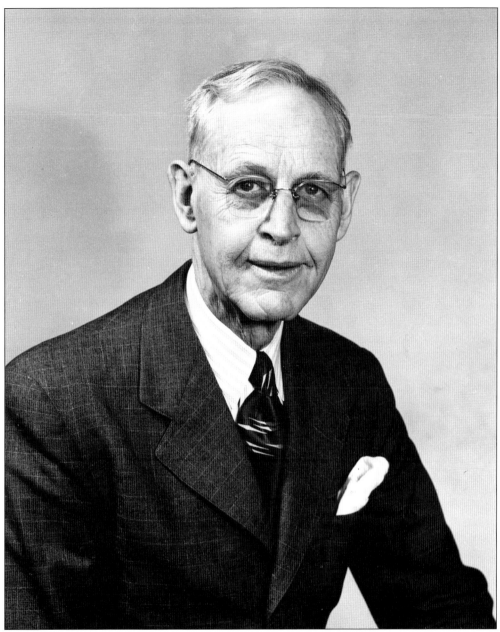

Born on August 12, 1878, Archibald Jeter Cloud graduated from the University of California, Berkeley. He began his 45-year career with the San Francisco Unified School District, teaching English at Lowell, the city's academic high school. He served as head of Lowell's English Department before accepting various district administrative positions. Spurred by the establishment of San Mateo Junior College, Cloud worked toward creating a college in San Francisco with federal monies from the Depression-era New Deal. On February 15, 1935, the Board of Education of the San Francisco Unified School District adopted a resolution to create a junior college as a separate unit. Appointed the same month as the first president, Cloud served until he reached age 65 in 1949, the district's then-mandatory retirement age. In 1954, CCSF named a new classroom and library building, Cloud Hall, in his honor.

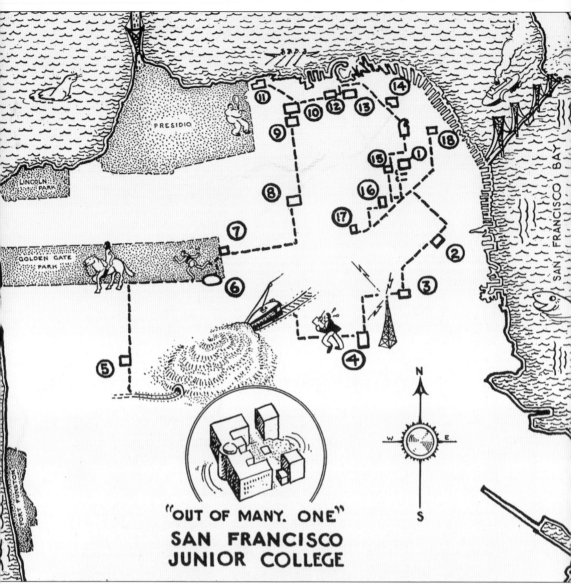

"OUT OF MANY. ONE"
SAN FRANCISCO
JUNIOR COLLEGE

Frustration on the part of students, faculty, and administration made it imperative to identify and secure one central location for a comprehensive college. This map in the September 14, 1938, *Guardsman*, the college newspaper, identifies all of the widely scattered locations, 18 in total, which would be merged eventually into the newly selected campus at Balboa Park if voters passed Proposition Number Four. Some of these locations included the North Beach Pool at Lombard and Columbus Streets, the San Francisco Riding Academy, Commerce High School, and Marina Junior High School. A tongue-in-cheek comment in the college newspaper was a rumor that if the proposition did not pass, "The college's newest location will be within the well-known city limits of a place called Los Angeles."

Instruction began on September 4, 1935, with morning classes at the University of California Extension Division building on Powell Street and afternoon classes at Galileo High School, pictured here. Because students were required to travel extensively between classes, they nicknamed it the "Trolley Car College." As population grew, additional sites were required. Thus from its inception, CCSF has reached into the community. Today, in addition to the main campus at Ocean and Phelan Avenues, there are 10 campuses, and courses are offered in a multitude of rented or leased locations throughout San Francisco enabling students to be educated in their own neighborhoods. The connection with Galileo continues; its students in early 2008 visited the main campus to learn more about Global Positioning Systems and Geographic Information Systems.

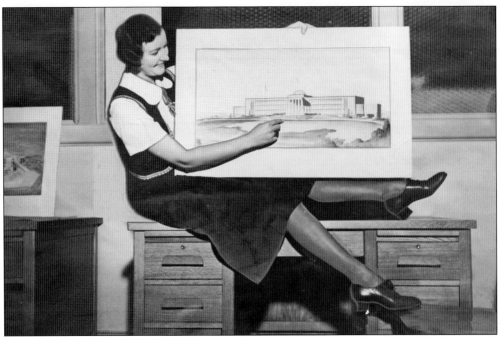

In the fall of 1937, Candace Striddle, employed by the Board of Education of the San Francisco Unified School District, poses, above, with Timothy Pflueger's drawing of Science Hall, the first permanent structure on campus. In this April 1937 photograph, below, three students, Jane Knight, Marie Stich, and Rosella Retallich, examine Pflueger's model of the proposed campus buildings. It included a separate library, a swimming pool, and a performing arts center. The last three facilities were not realized for over half a century. Pflueger, trained in the Beaux Arts movement, had a unified architectural and artistic vision for the college. The June 1941 issue of *Architect and Engineer* described him as "responsible for the work of more sculptors and mural painters in his buildings than any other western architect." (SFPL.)

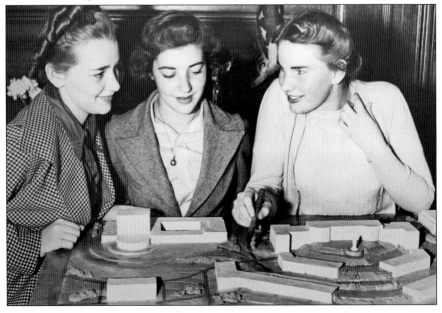

It was determined that $2,800,000 was necessary to realize the dream for a central campus. Of this amount, the federal government would grant 45 percent in New Deal funds, leaving the remainder for city voters to raise through a bond measure. Election day for Proposition Number Four was September 27, 1938, and students were encouraged to campaign energetically for its passage, as seen in this *Guardsman* advertisement.

VOTE YES!

PROPOSITION NUMBER 4
of
SAN FRANCISO'S BOND ISSUE

Will Insure a Complete
COLLEGE CAMPUS

SEPTEMBER 27, 1938

VOTE YES!

f tion.

Other Units To Follow Soon
Actual work on the latter units of the plant is scheduled to begin late this year, or, at the very latest, in January of 1939. Founda-

Mayor Rossi Acknowledges Gratitude For Part Played By College In Bond Issue Campaign

OFFICE OF THE MAYOR

San Francisco September 30, 1938

Mr. Robert Fex,

President—Associated Students,

San Francisco Junior College,

San Francisco, California.

Dear Mr. Fex:

In the victory of the School Bonds last Tuesday, I gratefully acknowledge the unselfish and influential help given by your Student Body.

I was amazed, on several occasions, during the campaign, to learn of the well-directed barrage of solicitations put forth by over one thousand students, over the telephone. The writing of twenty thousand personal letters from the students to their friends added to the realization, by our loyal voters, that something must be done, to house our youth at San Francisco Junior College. I know also, of the intelligent advantage your Press Committee took, of all opportunities to get your message over the radio.

In short, I believe the alert, able and unceasing help of the Students put the School Bonds over, with such a safe margin.

Kindly extend to all who joined in this effort, my thanks and congratulations, as Mayor, as well as personally.

Sincerely,

(Signed) ANGELO J. ROSSI,

Mayor

tion work for the first building, which is to contain classrooms and lecture halls, is already complete, and work on the erection of the building can start at any time.

Out of more than 149,000 ballots cast, returns showed that Proposition Number Four had received a two-thirds vote. Of the ballot's nine propositions, this school bond issue was the only one that passed, largely because of the participation of CCSF students. In this letter to Robert Fex, president of the Associated Students, San Francisco mayor Angelo J. Rossi praises the students' role in the campaign.

Sec. 562, P. L. & R.

SAN FRANCISCO
PUBLIC SCHOOLS BULLETIN

ISSUED BY THE SUPERINTENDENT OF SCHOOLS

VOL. X. SAN FRANCISCO, OCTOBER 3, 1938 NO. 8

School Bonds Given Overwhelming Majority

ON THE heels of the striking success of the $2,800,-000 school bond housing proposal at the polls on last Tuesday, Hon. Harold W. Ickes, Secretary of the Interior, on Wednesday complemented the proposition with a federal grant of $2,450,091, without which the bonds could not have been issued. The vote was: Yes—95,107, No—40,253.

Commenting on the favorable vote on Proposition No. 4, Richard E. Doyle, president of the Board of Education, said:

"The overwhelming vote in favor of the school bond issue is another evidence of the confidence which San Franciscans repose in the public schools. This is gratifying indeed to the commissioners of education as well as the administrative staff of the school system."

The telegram announcing the federal grant came on Wednesday while the glow of Tuesday's victory was still in evidence, and was received by Hon. Franck Havenner, representative in congress from the fourth district. It closed a long file of correspondence with Mr. Ickes which had been undertaken by the congressman during the past several weeks not only on behalf of the federal grant to complement the bonds, but an additional grant as well, known officially as Docket 1578. Both were allowed.

While the friends of the public schools were conducting an intensive campaign in the community to assure approval of the bonds, President Doyle, Commissioner C. Harold Caulfield, President A. J. Cloud, and Chief Deputy Superintendent John F. Brady were in constant communication with Washington. With Mr. Havenner they were able to get before Mr. Ickes, the singular importance of the school proposal. President Doyle talked with Washington almost nightly, in one instance conducting a three-way conversation with Congressman Havenner speaking from Del Monte, California. In another field Commissioner Caulfield enlisted the aid of Hon. John W. Studebaker, United States Commissioner of Education, with singular success.

Approval of the school bonds electrified the community. On all sides observers familiar with campaigns said the result, in view of the defeat of all other propositions was nothing short of phenomenal.

The joyful attitude of the elementary principals' group in view of the significant part they played in the campaign, was reflected at a meeting of principals on Wednesday which opened and closed with bouquets, real and verbal.

To Commissioner W. F. Benedict who conducted the central campaign for passage of the bonds, Superintendent Nourse wrote:

"Without the substantial aid given by you and your central committee to the passage of the school housing proposal, the result would have been different. Will you please extend the thanks of the Superintendent of Public Schools and his administrative staff to Mr. Fred H.

(Continued on Page 3)

The Voice of the People

A school bond election encompasses more than the title indicates. In a larger sense it is a referendum on the entire program of public education. When the result is as overwhelming as shown by returns from the election last Tuesday, teachers are justified in the thought that they are performing to the eminent satisfaction of the community the all important task of teaching.

No word of mine can testify to the high esteem in which the people hold their public schools as eloquently as did the citizens by their votes on last Tuesday.

It is indeed gratifying to the members of the Board of Education to know that public education has been given this renewed expression of confidence.

R E Doyle
President

To a Retired Teacher

How sweet to dream your auburn autumn dreams,
 To sit with placid smile
Mellowed with all the seasons of your years,
 And soft upon your lips
As web-spun lace o'er silken lavender
 When mother breathes.
What choice reward to whisper to your heart,
 Gold in the vesper glow;
To wrap yourself within the seamless robe
 Unerring hours have spun;
To watch the empty haste of passers-by
 Seeking what you have won;
To pray that truths and loves you sanctified
 Through dedicated days,
May as your testament of hope, abide
 Beyond the ends of time.
 —CHARLES F. WALSH,
 Lowell High School.

In a public school bulletin on October 3, 1938, Richard E. Doyle, president of the Board of Education of the San Francisco Unified School District, issued a statement, appearing in the box above, praising the overwhelming passage of the bond. One of the more effective means of alerting the public to the plight of CCSF students had been the screening in leading theaters of a movie depicting a student running all over town meeting his classes. In addition, President Cloud's assistant, Paul Pitman, organized the students who wrote over 20,000 personal letters and made thousands of telephone calls urging passage. *The Guardsman* printed 140,000 copies of the college newspaper, which were delivered to San Francisco homes.

After five years of planning, Archibald Cloud's dream was coming to fruition. Helen Davis and Mimi Colton, at the microphone, stand at attention next to school color bearers in this April 1937 photograph of the ground-breaking ceremony for Science Hall. The original plans also called for the construction of both a men's and women's gymnasium. (SFPL.)

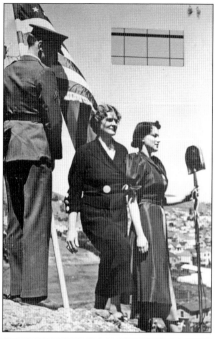

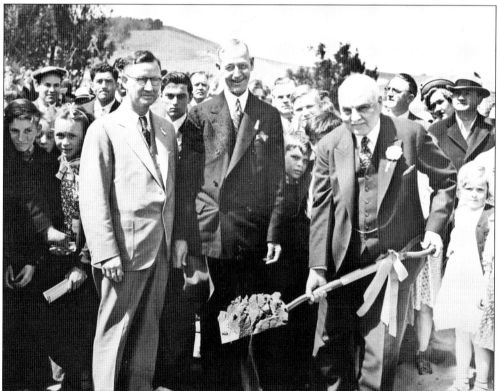

City officials, students, faculty, and visitors gathered on April 24, 1937, on the crest of a hill, atop a 40-foot wide rock, to observe the ground-breaking ceremony for Science Hall. President Cloud (middle) looks on as San Francisco mayor Angelo J. Rossi digs the first shovel of dirt. (SFPL.)

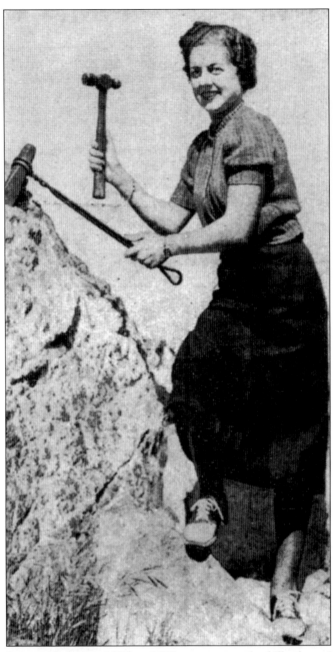

Marion Yager, who attended from 1936 to 1938, poses atop the hill where Science Hall was constructed. After receiving an associate in arts degree in business, she was employed by the Emporium and Capwells in San Francisco. Yager, now 92 and living in Texas, contacted the authors to share her photograph and memories. Shirley Breyer Black, who attended in 1935 and 1936, still remembers the long streetcar rides between classes and home. She put her business major to good use working for Edith Pence, assistant dean of women, and later for the Unified School District as head of the Audiovisual Department. She was the first woman to serve as president of a local union and still serves on MUNI's board. Her brother, Irving, was an attorney for the Board of Education of the San Francisco Unified School District and later for CCSF.

CCSF students Dorothy Trood, Muriel Nolan, and Janet Ball sweep dirt off the foundation of the new Science Hall, preparing for actual construction. (SFPL.)

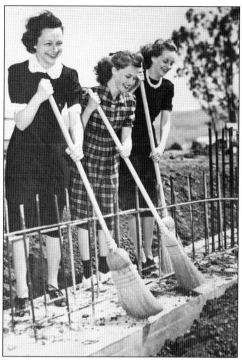

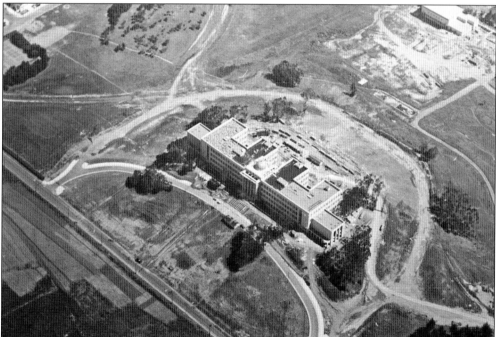

This 1940 aerial photograph shows an almost-completed classically designed Science Hall. The first floor held home economics and physics classes. Architectural drafting rooms, the radio broadcasting center, and chemistry laboratories were on the second floor. The third floor held biological sciences classes, business training rooms, and the library. The top right-hand corner of the photograph shows the north/women's gym. (SFPL.)

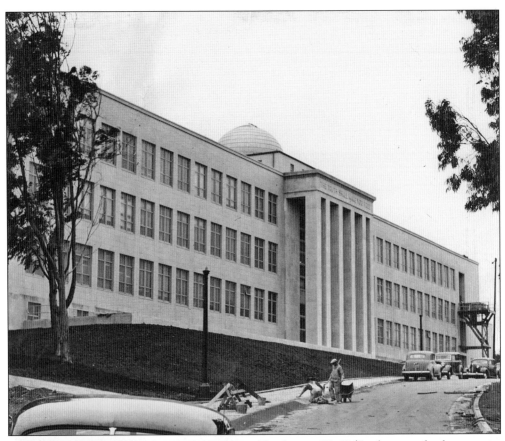

The August 15, 1940, photograph, above, shows Science Hall almost completed. Designed of reinforced Bedford limestone concrete mined in Indiana, the entrance portal faces west over the Pacific Ocean toward the Farallon Islands. Cloud and Pflueger chose the two-foot-high biblical inscription, "The Truth Shall Make You Free," to be placed above the main entrance. Students called the Science Hall bluff "pneumonia hill" because of the fierce winds, which at times approached 30 to 40 miles per hour, making it difficult to open the 200-pound doors at the main entrance on the west side. The block print at left, published in *The Guardsman* on October 22, 1940, celebrates the open house for the new Science Hall. The formal dedication was held on November 10, 1940, before 1,000 visitors and students. Part of the ceremony was rebroadcast nationally over KGO. (Above, SFPL.)

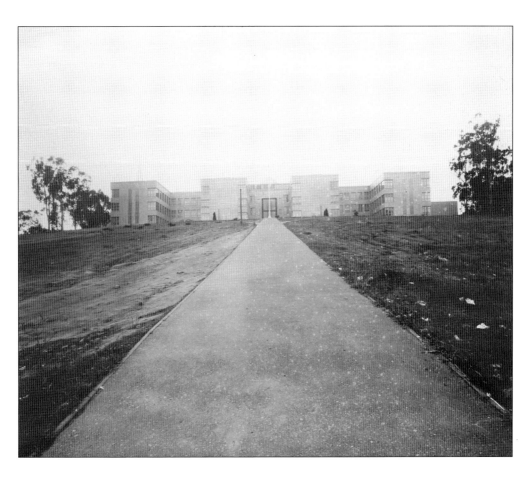

Gymnasiums for men and women were also a part of phase-one construction on the campus. The space between the two gyms was designated for a future swimming pool, which was not built. The photograph above shows the long, uphill path from the gyms to classrooms in Science Hall. The hike between buildings was described as a perilous mountain. Douglas Hutchings in his drawing below, which appeared in the January 17, 1945, issue of *The Guardsman*, suggested that to save the hearts and legs of the fairer sex, a sky-chair be constructed between the gyms and Science Hall. It was hoped that this new means of transportation would be an asset in providing a broad education. (Above, SFPL.)

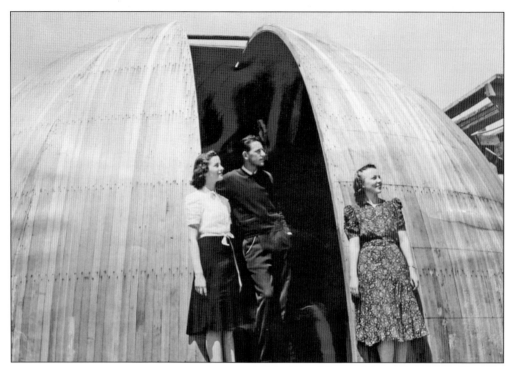

In 1940, Jean Chesley, Al Williams, and Gloria Miller pose in front of the observatory and dome on the top of Science Hall. The outbreak of war prevented the installation of the telescope, forcing students to observe the planets and stars from the open roof. In 1950, a star projector was installed turning the observatory ceiling into a planetarium. Finally, in 1978, a 14-inch Celestron telescope was installed. (SFPL.)

This May 1940 photograph shows an astronomy lab class on the roof of Science Hall. The gender difference in this group of students anticipates the war years when male students would be serving in the armed forces.

In the 1950s, George Green, the first geology instructor, points to a map, still on display in the Earth Sciences Department. On the wall to the left are reproductions of maps created for the Golden Gate International Exposition by Mexican artist Miguel Covarrubias. A decade earlier, Green had found dinosaur footprints in a quarry near the mouth of the Connecticut River. He tied the slab of rock with the footprints to the roof of his car. Today it is installed in the basement of Science Hall. Below is a 2009 photograph of the main classroom in the Earth Sciences Department with a large plesiosaur skeleton on the wall to the right, on loan from the California Academy of Sciences. It is part of The Story of Time and Life—an exhibit that covers the evolution of the universe, the solar system, and life on Earth. (Below, courtesy of Katryn Wiese.)

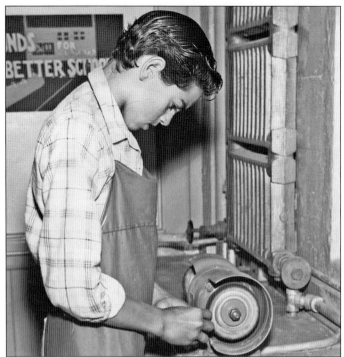

With a poster declaring that bonds make for better schools, a young engineering student is seen in the basement of Science Hall in this 1956 photograph. One of the college's more prominent graduates of the engineering program in the late 1960s was Noel Lee. From CCSF, Lee transferred to Cal Poly as an engineering major. In the late 1970s, he founded Monster Cable Products, Inc., which produces high performance consumer electronics accessories.

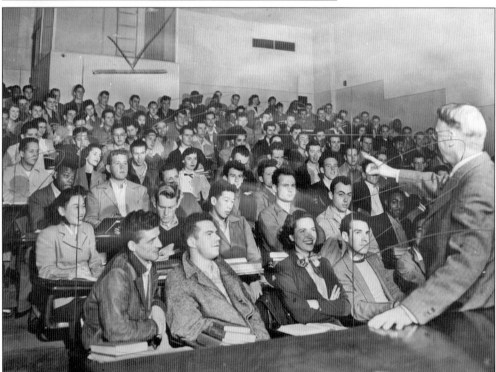

In 1942, the students in this large lecture class listen attentively to Prof. W. D. Forbes as he gives a lecture in first-year chemistry. As seen in this class with many more males than females, World War II had not yet begun to siphon off male students. (SFPL.)

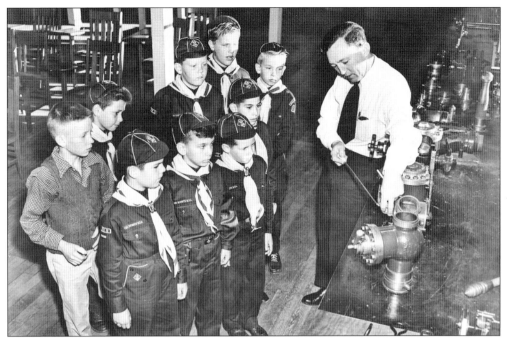

Shown here with Lieutenant A. Potten of the San Francisco Fire Department, Cub Scouts of Troop 95 toured the Fire College in the fall of 1949. They learned the intricacies of fire control and were allowed to turn on fire alarms. Years later, Robert L. Demmons graduated from this program. In 1996, he became the first African American to head the San Francisco Fire Department. He served as chief until 2000.

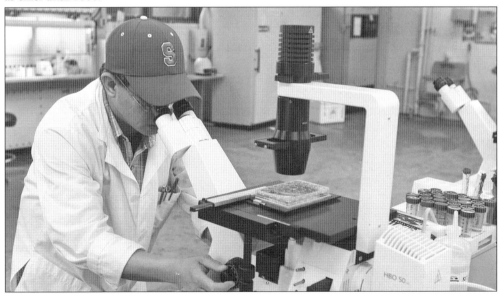

Edwin Masangkay, one of the first students to receive a stem cell certificate, graduated from CCSF's Bridge to Biotech Program, begun in 2006. He is pictured in the cell culture laboratory observing cultured mouse embryonic stem cells using an inverted light microscope. In 2010, the college received a grant of $1,110,608 from the California Institute for Regenerative Medicine, making it possible to offer 10 full-time internships. (Davey.)

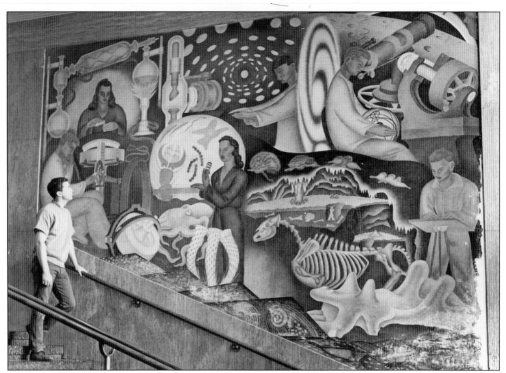

Frederick Olmsted agreed in 1941 to paint two murals for the west entrance stairs of Science Hall. Using muted colors and small brushstrokes, he centered the theme on the "Theory of Science," depicting students engaged in various branches of scientific research. One panel, pictured here in 1955, already shows signs of damage on the bottom and right. Because of seven decades of such damage, restoration was begun in late 2001. Pictured below, standing in front of the opposite panel, from left to right are Peter Goldstein, vice chancellor; Lourdan Kimbrell, former student and originator of the restoration project; Julia Bergman and Will Maynez, Works of Art Committee members; and Nathan Zakheim, art conservator; and Nathan's son, Kuvaleshaya Zakehim. Funding was provided by Proposition A Allocation for Science Hall, Partnership for Excellence, and the Associated Students. (Below, courtesy of Mark Albright.)

New Deal funds paid for 45 percent of the two-story, state-of-the-art gyms constructed some 760 feet down the eastern slope as viewed from inside Science Hall. Left of the flagpole is the women's gym and to the right, a portion of the men's gym, with a basketball floor as large as any Bay Area university and bleachers that seated up to 3,000 spectators. Before the gyms were built, basketball teams held home games either at the Kezar Pavillion courts or at the Galileo High School gym. Male tennis players traveled either to the Golden Gate Park courts or the Palace of Fine Arts, while their female counterparts used the courts at Funston Field in the Marina. The women's basketball, volleyball, and badminton teams played in the Galileo High School gym, which also held fencing, modern and folk dancing, shuffleboard, and Ping-Pong classes. (SFPL.)

Because over 1,200 students took the K streetcar to the college in 1940, the municipal railway extended the tracks two blocks further east on Ocean Avenue. Students still had to walk across Ocean Avenue and then three blocks east to Phelan Avenue and climb the steep hill to Science Hall. The Market Street Railway begrudgingly adjusted the route of the Number 10 bus so that it came up to the front door of Science Hall. (SFPL.)

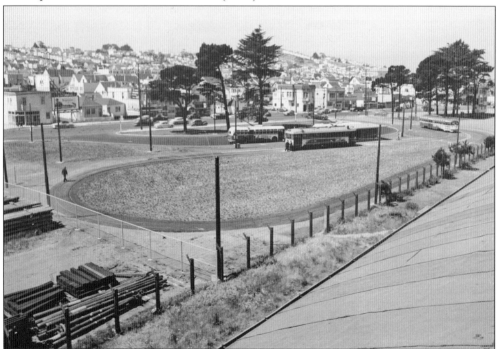

This view of the Phelan Avenue Loop looking southwest shows a major transportation hub for the college. Today the vast majority of students continue to take public transportation, including BART. Several bus lines still stop at the Loop. (SFPL.)

Two

THE GOLDEN GATE INTERNATIONAL EXPOSITION AT TREASURE ISLAND, DIEGO RIVERA, AND ART FOR THE COLLEGE

CCSF student Marion MacKillop's woodcut illustrates college support for the Golden Gate International Exposition, which celebrated new relationships among Pacific Rim countries, the opening of the Bay and Golden Gate Bridges, and Pan American Airway's China Clipper flights. Five CCSF instructors chose the name "The Gay Way" for the amusement zone. CCSF sophomore Alice Pearson won the statewide essay contest on "Contributions of the Countries of the Pacific Area to Contemporary Civilization."

April the 15 of 1940
Mr Timoty Pflueger
Hotel Ritz. Mexico City.

Dear Tim:

I am most happy To accept your kind invitation To participate in the G.G.I.E. and built a fresco in The Palace of Fine Arts, on The condition That I be permited To make this my personal contribution Toward the promotion of good will between ours countries and because of my great affection for my friends in San Francisco who made my previous stay in San Francisco such a pleasent one.

For years I have felt that the real art of the Americas most came as a result of the fusion of the machinism and new creative power of the nord with the Tradition rooted in the soil of the soute, The Toltecs, Tarascans, Mayas, Incas, etc, and would like To choose That as the subjet of my mural.

I am enthusiastic about this projet and shall look forward easerly To the pleasure of again seeing and being with you and my many other friends in San Francisco

Sincerely.
Diego Rivera.

With New Deal funding, architect Timothy Pflueger invited Mexican muralist Diego Rivera to participate in the "Art in Action" program on Treasure Island. In this April 15, 1940, letter, Rivera accepts. His mural, titled the *Marriage of the Artistic Expression of the North and of the South on this Continent*, a gift to the college, was his largest contiguous piece, and the last work he created in the United States. During an earlier nine-month visit to San Francisco in 1930–1931, he created three fresco murals: *Allegory of California* at the Old Stock Exchange, *The Making of a Fresco Showing the Building of a City* at the San Francisco Art Institute, and a small fresco picturing the grandchildren of Rosalie Stern, now in Stern Hall at the University of California, Berkeley.

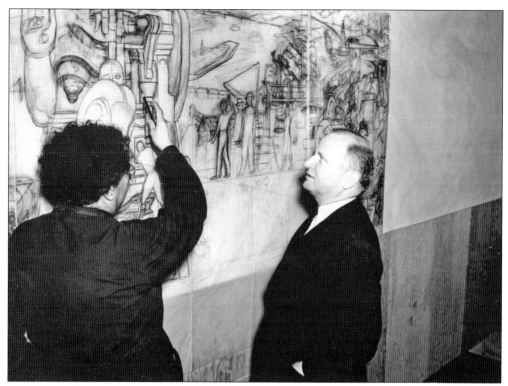

Rivera and Pflueger study mural details in the sketch, which was approved by the San Francisco Art Commission on July 25, 1940. This sketch remained displayed in a workroom behind the mural during the project before it disappeared in late November. Fortunately, Rivera's principal assistant, Emmy Lou Packard, saved large cartoons of the mural and donated them to the San Francisco Museum of Modern Art. The valuable sketch was never found.

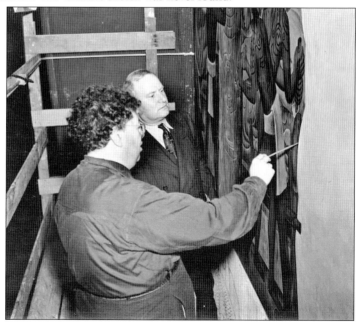

Pflueger watches Rivera paint the mural, which is composed of 10 steel-framed panels and painted al fresco in the manner of Italian Renaissance masters with paint applied to wet plaster. Rivera completed the mural on November 29, 1940, and on Sunday afternoon, December 1, newspapers reported that nearly 30,000 people viewed it before it was crated and stored on campus for the next 20 years.

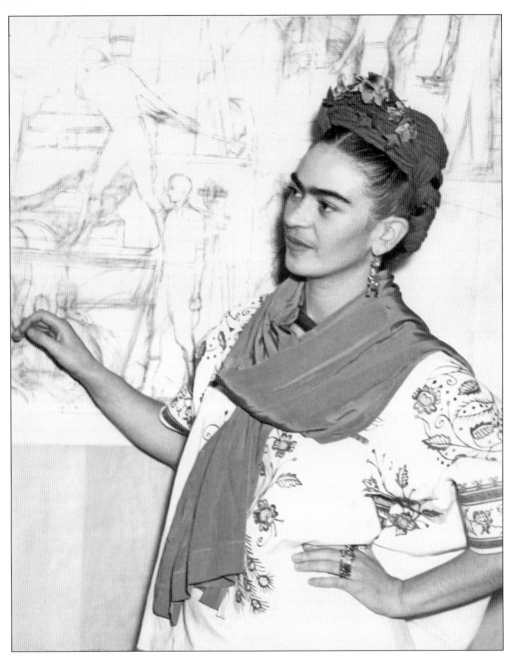

Self-taught, Frida Kahlo was influenced by the indigenous Mexican culture of her homeland. A serious bus accident resulted in her enduring 35 operations and chronic pain, a recurring theme in her paintings. Of a total of 143 works, she painted 55 self-portraits using vibrant colors and dramatic symbolism. She is portrayed in the mural in the traditional dress of Tehuantepec, wearing hand-shaped earrings, a 1939 gift from Pablo Picasso. In a December 1940 letter to engineer Sigmund Firestone, she wrote, "How I wish you could of [*sic*] seen the fresco Diego just finished here. It is in my opinion the best painting he ever did. The opening was a great success . . . Diego was so happy! Just like a little boy, he was shy and very happy at the same time." (Courtesy of Mara De Anda.)

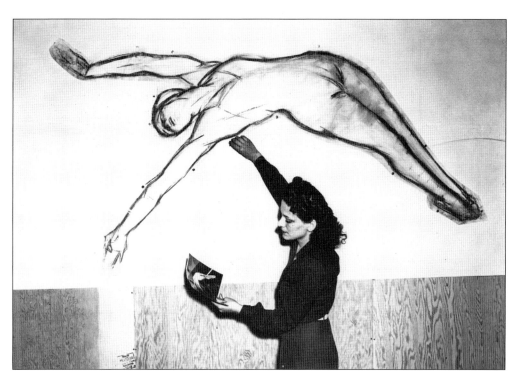

Irene de Bohus sketches an image of Helen Crlenkovich for Panel 2 of the mural. Crlenkovich, a physical education major at CCSF, also appears in Panel 4. Before she turned professional in 1946, she had won nine Amateur Athletic Union diving championships. Rivera and Emmy Lou Packard, below, work on a section of Panel 1. When the mural was installed in the college theater lobby, Packard was hired to repair a hole in Panel 5 incurred while a fireman was putting out a fire in the shed at Treasure Island, where it was initially stored. The mural will be undergoing conservation work in collaboration with the Mexican government, the work to be done by female art conservators, then eventually installed as the centerpiece in a proposed new classroom/laboratory building celebrating the arts.

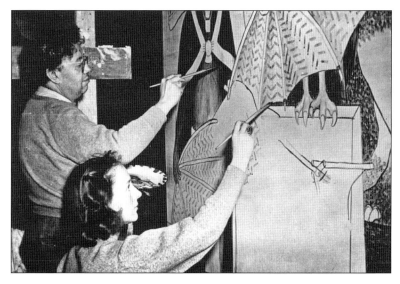

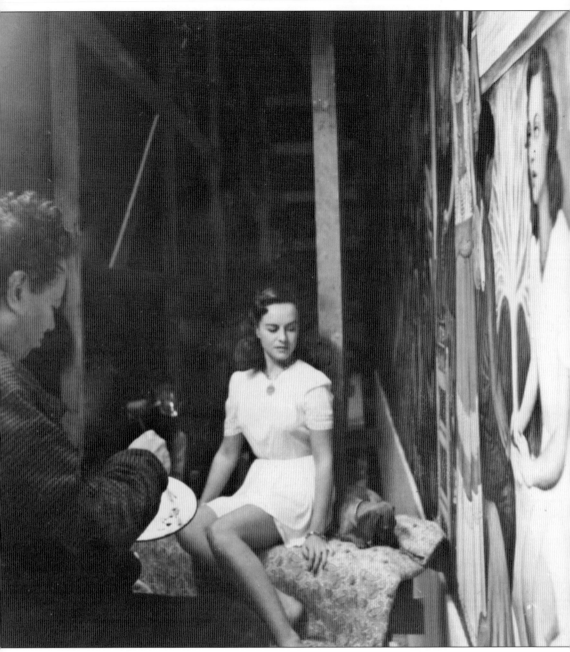

According to Mona Hofmann, one of his assistants, Rivera wanted to create the mural "solely with the help of women and at first, just one, namely me," she wrote. Because he had been told the mural would be installed in a women's college, Rivera wanted to present the history of women in the making of America. Therefore numerous women are portrayed, including film star Paulette Goddard, who posed for Rivera at Treasure Island in 1940. In the photograph above is an almost-completed portrait of the actress holding a Ceiba tree, the Mayan Tree of Life. In the final rendition, Rivera depicts himself sitting next to her, holding hands. When asked why, he remarked, "It means closer Pan-Americanism." Over the course of several years, Rivera painted a total of 12 portraits of Goddard. (Courtesy of Donald Cairns.)

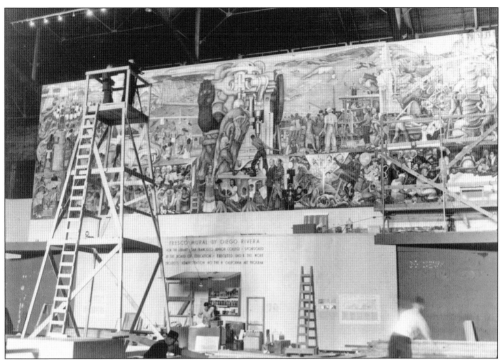

The photograph above shows the nearly completed mural, which Pflueger intended to install in CCSF's library. Insured for $50,000 with Lloyd's of London, it was packed in 10 sixteen-foot square boxes, moved across the Bay Bridge early in the morning of June 21, 1942, and placed in a shed next to the men's gym. World War II halted campus construction, and the library was never built. For the next two decades, the mural remained stored until an addition to the gym required the destruction of the storage shed. In 1960, the mural was placed in the lobby of the theater, which was renamed the Diego Rivera Theater in 1993. In the June 16, 1959, photograph below, Dr. Harold Spears, superintendent of schools (right) and Dr. Louis Conlan, college president, hold a framed reproduction with an uncrated panel in the background. (Above, Bancroft; below, SFPL.)

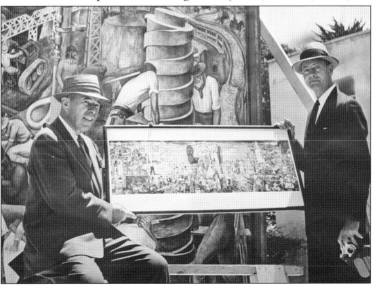

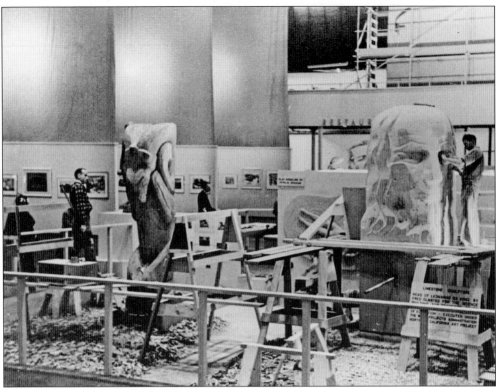

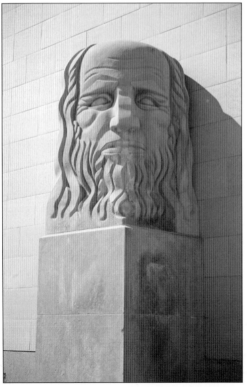

In the photograph above, of "Art in Action," Dudley Carter's redwood bighorn mountain ram is nearing completion, while Frederick Olmsted, grandson of Frederick Law Olmsted, architect of New York City's Central Park, is seen carving his 9-ton Bedford limestone bust of Leonardo da Vinci, the Italian Renaissance painter, architect, and inventor, pictured left. The bust of da Vinci, representing science of the past, was completed at the exposition. To represent science of the present, Olmsted, in January 1941, began carving a bust of Thomas Edison on campus in full view of the students and faculty. Both busts, installed on the east side of Science Hall, were formally dedicated on April 26, 1941. They were cleaned and restored by conservator Karen Fix in 2007. (Above, courtesy of California Historical Society, (FN-30712); left, Menendez.)

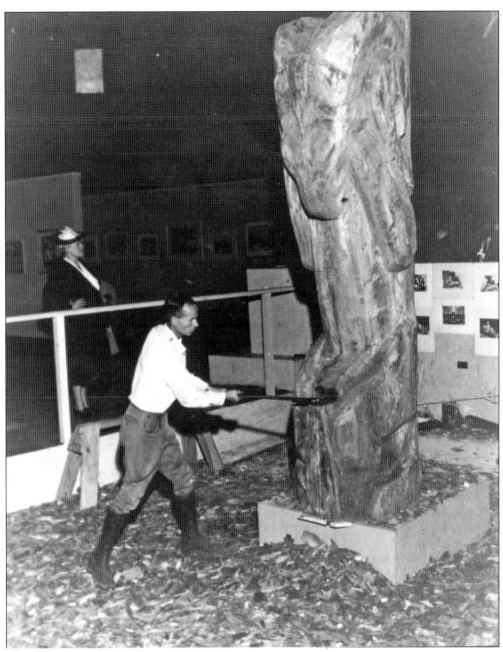

Beginning his career carving soap and later observing the Kwakiutl and Haidi carvers of his native British Columbia, Carter, using their techniques, is seen here refining his redwood ram with a double-bladed axe, littering the floor of the Pan American Clipper hangar. Rivera, working on scaffolding high above Carter's position, became fascinated by the Canadian's use of a simple tool and portrayed him three times in his mural. In comparing himself with the Mexican artist, Carter wrote that weighing only 122 pounds he had to wield a heavy axe and attack a 30-ton redwood tree trunk while Rivera, who weighed in at 315 pounds, merely had to wield a brush. Others who closely observed Carter included Sonja Henie, Edward G. Robinson, and Charles Laughton, all visitors to the Exposition at Treasure Island.

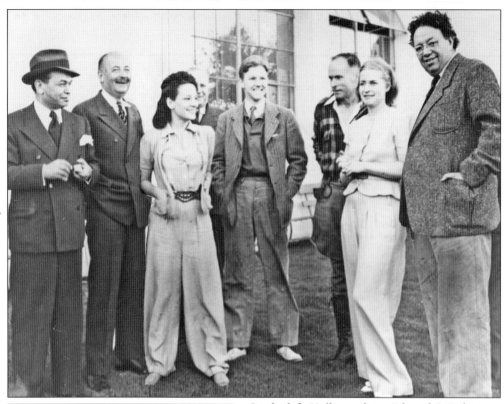

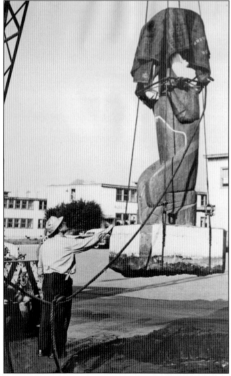

On the left, Hollywood star Edward G. Robinson gathers with others to watch Dudley Carter's *Ram* being transported to CCSF. Ottorino Ronchi, president of the San Francisco Art Commission; Irene De Bohus, Timothy Pflueger, Johnny Cummings, Dudley Carter, Mona Hofmann, and Diego Rivera complete this group. Robinson, like Paulette Goddard, also came in person to pose for Rivera at Treasure Island for a scene from his 1939 film *Confessions of a Nazi Spy*. (Courtesy of Donald Cairns.)

The *Ram*, carved in 30 days from a single redwood log, became the college mascot and once stood outside the men's gym. On March 12, 1947, it was moved to the entrance of the West Campus. No longer viewed as a work of art, it became a target for vandalism. The Associated Students funded its removal and placement in front of George D. Smith Hall on January 3, 1956. Engineering students designed a special pedestal for it. (SFPL.)

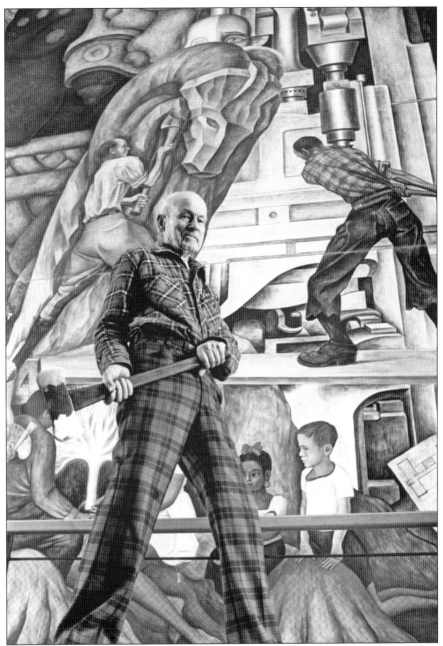

Carter poses before the mural in front of the Mexican artist's depiction of him carving the *Ram*. During the "Art in Action" program, Carter also created *The Goddess of the Forest* to represent important principles in the totem design of the Northwest Coast Indians. He gave the *Ram* to the college and the *Goddess* to the city. The latter, carved out of a single 26-foot redwood log, stood in Golden Gate Park, where it suffered extensive water damage to the lower half before being restored by Art Department instructor Roger Baird in 1992. Now only 15 feet tall, it stands in the Diego Rivera Theater lobby on permanent loan from the San Francisco Art Commission. Baird also saved an eagle that had been on the *Goddess's* back. Today it is housed in the Rosenberg Library with the Rivera Collection. (Courtesy of Fred Berensmeier.)

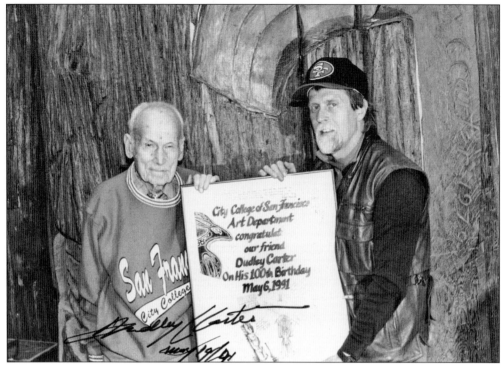

Roger Baird honors Dudley Carter on his 100th birthday in this 1991 photograph in Bellevue, Washington. In 1983, Carter, in his 90s, returned to campus and restored the Ram to its original redwood surface, removing coats of paint with his original axe. Today along with Carter's *The Beast*, a coyote or wolf howling at the moon, they stand in the main lobby of Conlan Hall. (Courtesy of Roger Baird.)

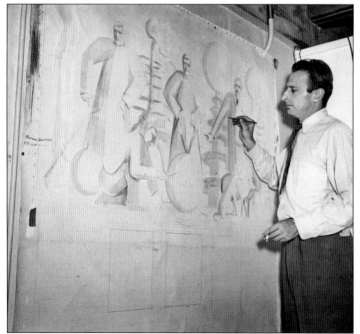

Zurich-born Herman Volz also participated in Pflueger's "Art in Action" program. He is seen here sketching a panel of his mosaic murals made of pebble-sized pieces of polished marble gathered from all over the world. Mounted in the north portico of Science Hall, this mural represents the organic sciences of physics, chemistry, biology, and mathematics. Volz resealed the tiles in 1968; they were restored and polished by Genevieve Baird in 2005. (Courtesy of Friedel Volz.)

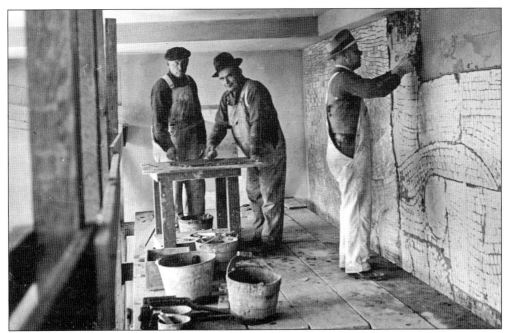

In this *c.* 1940 photograph, workmen are placing cut stones into one of Volz's murals. This second mural was mounted on the south portico of Science Hall and represents the applied sciences of aeronautical engineering, architecture, and mechanical engineering. The grasshopper, bat, flying fish, and beaver, as well as the hull of a ship, the micrometer, and the rope and pulley are also displayed along with three towering figures holding a caliper and compass. (Courtesy of Friedel Volz.)

Three large figures loom above a doorway on the north side of Science Hall. They represent the organic sciences. A fourth figure measures the latitude and longitude of the earth. Beneath these figures are abstract shapes representing such diverse fields as chemistry, archeology, and cartography. A staff of eight workmen spent two years installing the mural. (Menendez.)

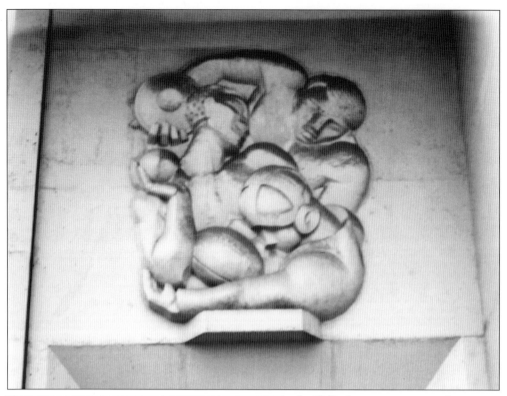

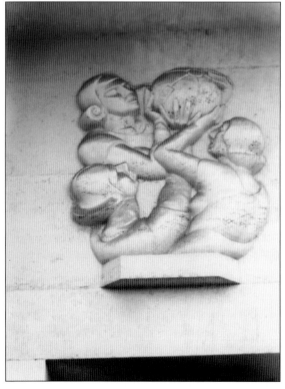

In 1940, three concrete panels depicting athletics, attributed to Sargent Claude Johnson, a prominent African American artist, were mounted over the doors of the gyms. One relief, weighing more than 9,000 pounds, above, shows three male figures holding a discus, shot, and football; the second panel, left, weighing more than 10,000 pounds, depicts three female figures surrounding a medicine ball. A third, not pictured here, shows a single female figure holding a tennis racket. These figures will be reinstalled on the retaining wall of the new soccer field. Johnson also created a giant bas relief panel of sports figures for Washington High School, on Geary Boulevard, and several bas reliefs at the Maritime Museum at Aquatic Park. The San Francisco Museum of Modern Art holds several of his works, including his 1933 sculpture *Forever Free*.

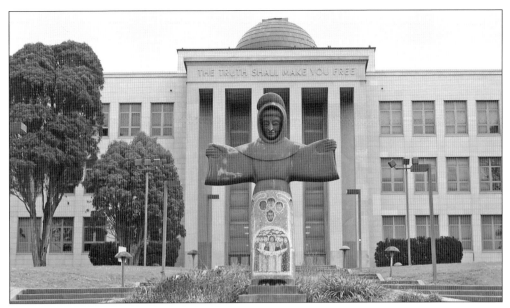

The 9-foot-tall *St. Francis of the Guns* by Beniamino Bufano, completed in 1969, above, was forged in Italy of bronze and gunmetal and decorated with mosaic tiles. The statue includes the mosaic faces of John F. Kennedy, Robert F. Kennedy, Martin Luther King Jr., and Abraham Lincoln, all victims of assassinations by handguns, and a multiracial children's chorus, below. In the wake of the 1968 assassinations, Bufano was commissioned to create this piece by San Francisco mayor Joseph Alioto, who initiated a voluntary drive for residents to turn in their handguns. Some 2,000 guns were collected, and Bufano incorporated the gunmetal into his sculpture. Mayor George Moscone, who was later assassinated, dedicated the sculpture, which is on permanent loan from the San Francisco Art Commission. (Herman.)

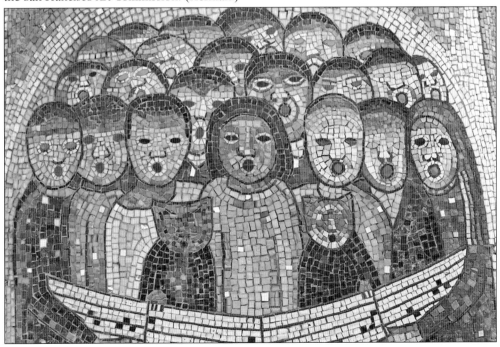

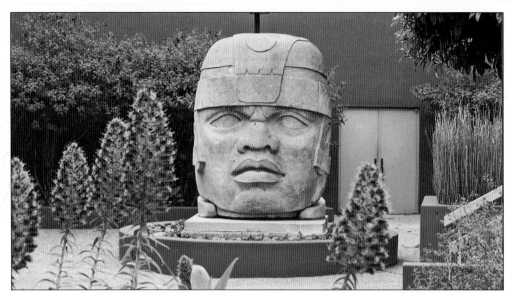

A gift from Veracruz governor Miguel Alemán Velasco, *El Rey* is a replica of an Olmec head, crafted from volcanic tuff in 2004 by Ignacio Perez Solano. The 9-foot-tall, 14-ton head is mounted in the courtyard of the Diego Rivera Theater. One of only five such heads in the United States, it is viewed by some to represent the "mother culture" of Mexico. (Herman.)

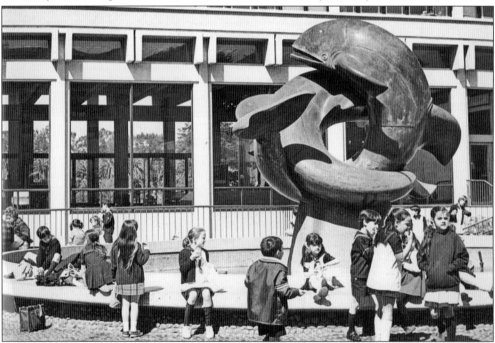

This whale fountain was created at the Golden Gate International Exposition by Robert Howard and designed for the San Francisco Building. In 1958, it was moved to the courtyard of the California Academy of Sciences in Golden Gate Park, as seen in this photograph. In collaboration with the San Francisco Art Commission, it will be restored and installed on the lawn in front of CCSF's new Community Health and Wellness Center. (Courtesy of the California Academy of Sciences.)

Three

WORLD WAR II
AND BEYOND

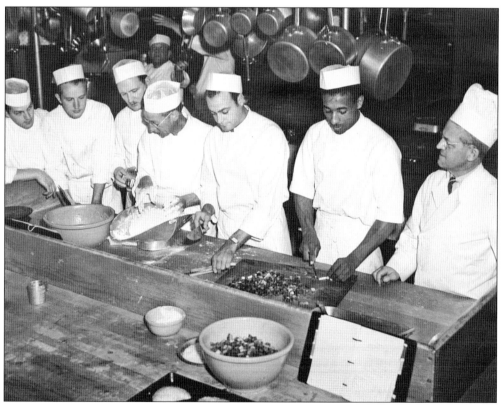

During the war, the college emphasized skill-oriented courses, offered the first summer session, and added non-credit adult extension courses, including the training of air wardens in chemical warfare and civilian evacuation. The Culinary Arts Department trained 600 Merchant Marine cooks, bakers, and stewards. This 1943 photograph shows seamen, from left to right, Byron Randall, George Gutekunst, Alfred Geiger, Edward Johnson, Alvin Sundberg, and William Edwards, as instructor Ernst Hjorth observes. (SFPL.)

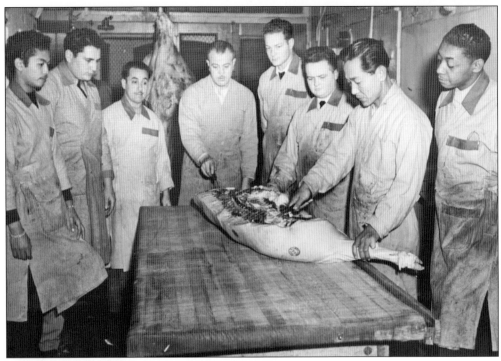

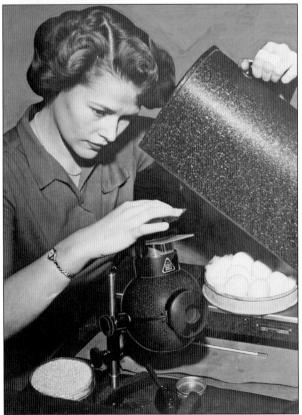

Learning the art of butchering in the Maritime Service Upgrading School in this March 1944 photograph are, from left to right, Jesse Porter Jr., Gio Samut, Arthur Brazil, instructor Virgil Milanesio, William Beatty, Shelly C. White, Bernardino Leyo, and McNickles White. Classes were also held at Galileo and Mission High Schools and the naval shipyard cafeteria at Hunter's Point. (SFPL.)

All campus departments modified courses to meet the war effort. The business faculty taught emergency war workers shorthand and transcription, while the Social Sciences Department taught courses in "Winning the War" and the "History of Air Power." The Biology Department taught a course in backyard poultry raising as reflected by this 1943 photograph in which Marilyn Brunton oversees the incubation of eggs. (SFPL.)

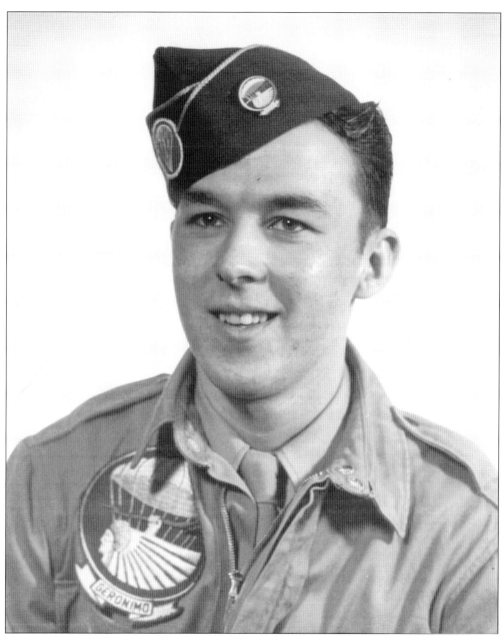

Following his military service as a paratrooper with the 101st Airborne Division, Reginald Yardley Alexander attended CCSF in 1946 before transferring to San Francisco State College. For over half a century, he served the San Francisco Unified District as a counselor, principal of two city high schools, administrator, and finally as vice chancellor of certificated services at CCSF. On June 6, 2009, he returned to Normandy for the invasion's 65th anniversary to receive the Légion d'Honneur, France's highest decoration for service to the French people. Another prominent faculty member was Joe Rosenthal, winner of six awards for photography. He is best known as the Pulitzer Prize–winning photographer of the famous flag raising by Marines at Mount Suribachi in Iwo Jima. In 1948, he taught Press Photography 87A at the college. (Courtesy of Bonnie Alexander.)

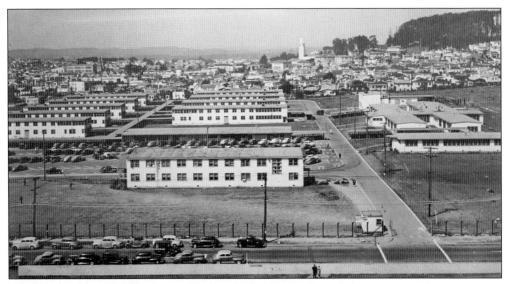

A close-up of the West Campus with the WAVES facilities in the foreground also shows Timothy Pflueger's El Rey Theater in the background. In 1944, the Navy Department built this temporary military base consisting of 15 sizeable buildings, including a cafeteria and auditorium. Located west of Science Hall, this site earlier held a dog racing track, and later vegetable gardens, and served as storage for sewer and gas pipes. (SFPL.)

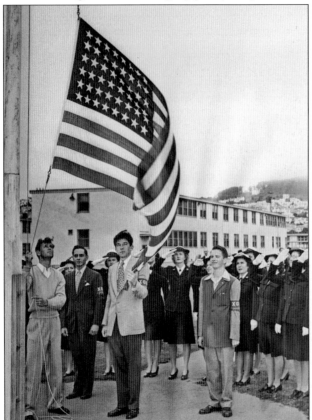

On September 13, 1946, college veterans, from left, Albert Moffatt, Les Holden, Richard Morse, and Robert Bertram raise the American flag as WAVES stand at attention during ceremonies turning their facility over to the college. Seven barracks were converted into classrooms, three into dormitories for veterans, and Building 13, "The Waldorf," became home to 50 married couples—rent in 1946 was $30 a month. The auditorium was used for dances, music classes, and rallies. (SFPL.)

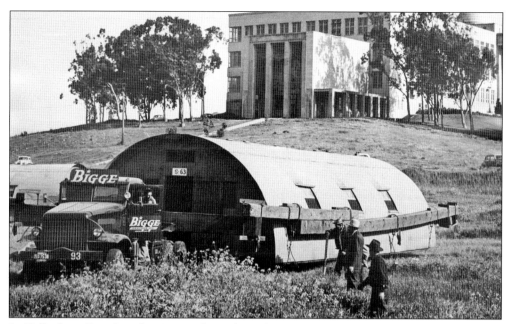

In 1943, the college bought 18 acres from the Park Commission along Judson Avenue and, with money from the Board of Education of the San Francisco Unified School District, purchased 25 surplus Quonset huts from the Federal Housing Authority for Hurley Village. Each hut, painted a shiny aluminum, complete with a house number, mailbox, sidewalks and streets, housed two families in a two-bedroom, one-bathroom apartment. This hut has just been delivered from Camp Parks in Livermore. (SFPL.)

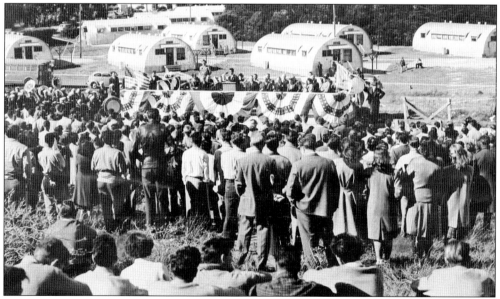

Hurley Village was dedicated on October 3, 1946, in honor of Maj. John J. Hurley, varsity swimming team coach who died in combat. An additional 160 one-bedroom units for married couples, constructed to the east, became available in the fall of 1946. *The Guardsman* described the village as a "Town within a town—a living testimonial to the gritty people who are successfully completing an education, while serving an apprenticeship in family ways." (SFPL.)

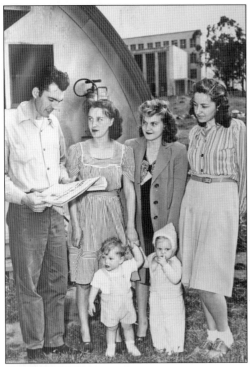

Walter Meyer, a navy veteran; Rhoda Larquier from Manchester, England, wife of an army veteran; Laura Paratore, wife of a former flight officer; and Mrs. Meyer confer over a news article before one of the Quonset huts in Hurley village in this April 1947 photograph. The children are Paul Larquier and Karen Paratore. Science Hall can be seen in the background. (SFPL.)

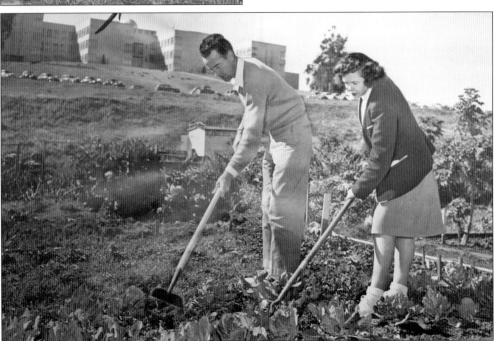

Horticultural staff taught classes on gardening and then offered students victory garden plots on campus or at Laguna Honda. From 1944 to 1948, CCSF received the highest award granted by the National Victory Garden Institute for gardens and home food preservation programs. At war's end, the plots became Freedom Gardens. In this March 1948 photograph, Joe Hassing of San Francisco and Audrey Bach of Oakland are busy hoeing vegetables. (SFPL.)

In 1968, the "Brig" school at Treasure Island Naval Station was opened to give sailors, who were confined, an opportunity to complete a high school education. Evelyn Press, then principal of John Adams Adult School, which administered the program, appears in this 1971 photograph. After five weeks, one student wrote, "I feel now that I do care for myself . . . and I'm concerned about my future in or out of the service." (Courtesy of Jim Martin.)

Military personnel participated in this program in 1972 to prepare for civilian life. Developed by John O'Connell Evening School, in conjunction with shipyard educators, the training was taken over by the College District, cosponsored by Hunter's Point Shipyard School and the Veterans Administration. Students took classes for GED requirements or refresher courses for college admission or technical training programs. Special needs for Iraq and Afghanistan veterans are currently being addressed by CCSF.

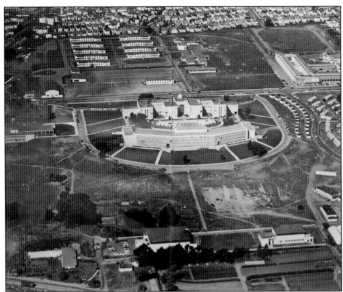

This 1955 aerial view with the gyms in the foreground features Cloud Hall, Science Hall, and Hurley Village with its Quonset huts to the far right and small, square one-bedroom units in between. The campus provided 217 veteran housing units under control of the city's Housing Authority. Riordan Catholic High School, built in 1949, is in the top right-hand corner with the WAVES facilities to the left. (SFPL.)

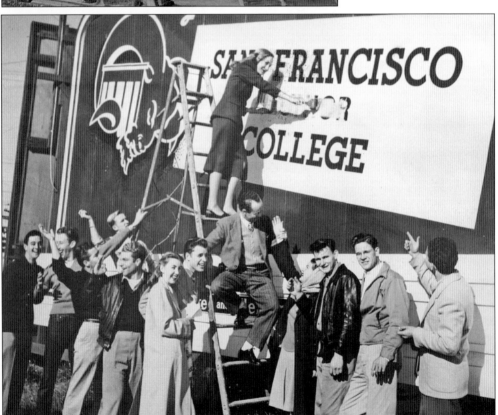

One result of the influx of veterans was a name change from San Francisco Junior College to City College of San Francisco. Veterans, who dominated the student council, on April 18, 1947, unanimously voted to remove "junior" from the name, believing it carried a stigma of adolescence, causing confusion with junior high schools. The following year, voters passed the second bond measure providing funding for future campus growth. (SFPL.)

Four

THE MAIN CAMPUS GROWS TO COMPLETION

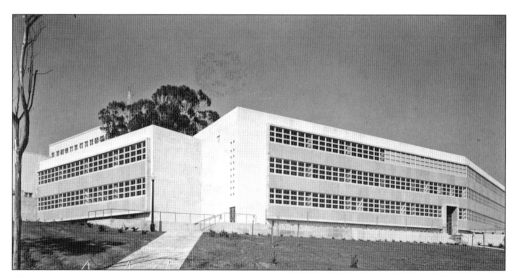

Pflueger's death resulted in his brother Milton becoming college architect and the end to a unified architectural and artistic vision. This ultramodern classroom building, approved in August 1950 by the Board of Education of the San Francisco Unified School District, was constructed on the eastern slope behind Science Hall and named in honor of former president Archibald Cloud. The ground-breaking ceremony, held in April 1952, was preceded by a ball at the Palace Hotel Ballroom.

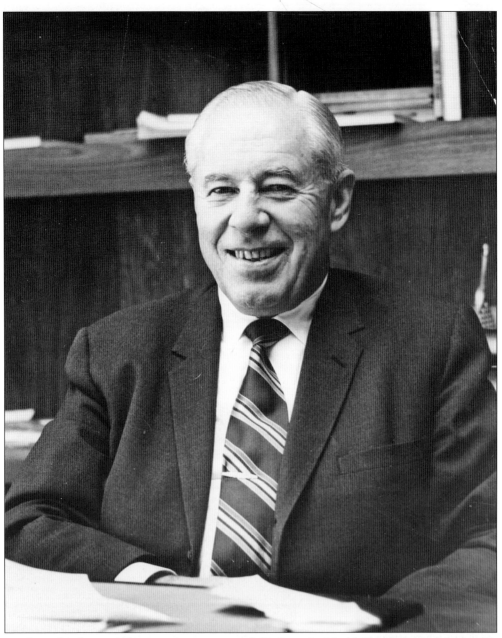

Reaching the then-mandatory retirement age of 65, Pres. Archibald Cloud stepped down. His successor, Dr. Louis G. "Dutch" Conlan, is pictured above. A graduate of Commerce High School, Conlan attended Saint Mary's College, where he played quarterback for three years, winning in 1926 a nomination for All-American honors. While employed as coach of St. Mary's freshmen football team, he attended Hastings School of Law, receiving his jurisprudence degree in 1929. He later earned an Ed.D. from the University of California, Berkeley. Unable to find a position practicing law, he became head football and basketball coach at Commerce High School until the fall of 1935, when he joined the Physical Education Department at CCSF. He taught introductory business law classes and headed the college's effort to pass the 1938 bond issue, which led to funding the initial campus construction.

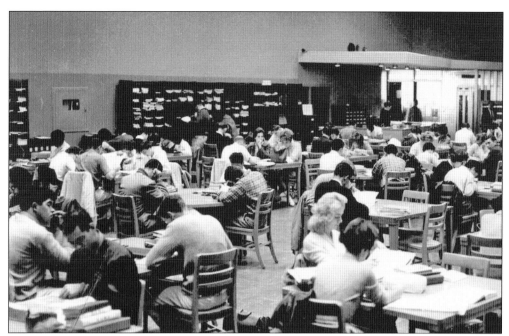

Library services were first provided at Galileo High School, with reference materials in a Pacific Gas and Electric Company building on Sutter Street. When Science Hall was completed, the library shared the third floor. With the construction of Cloud Hall, the library moved and occupied most of the third floor. In this 1960s photograph, students are seen studying in this poorly designed but heavily used reading room.

Stephen Levinson, who taught in the English Department for 37 years, created the Center of Independent Learning (COIL) in the library where students could check out supplemental classroom materials. This facility evolved into the Study Center and eventually into the Learning Assistance Center. The latter includes the Writing Success Project, the Reading Lab, the Tutorial Center, an academic computer lab, counselors, and other support services.

59

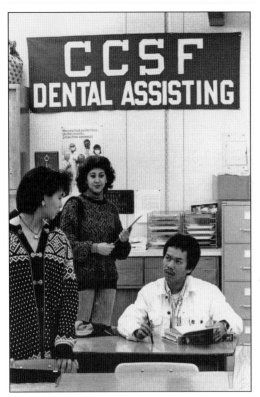

A variety of instructional programs, including business, drafting, architecture, home economics, and the Fire College were initially housed in Cloud Hall. Dental hygiene and dentistry classes appeared in the college catalog as early as 1936–1937, and the programs of dental assisting and dental hygiene appeared for the first time in the 1953–1954 catalog. This photograph to the left shows the office of the college's Dental Assisting Department in the 1980s. In the January 1960 photograph below, a group of program graduates pose. (Left, courtesy of Rick Gerharter.)

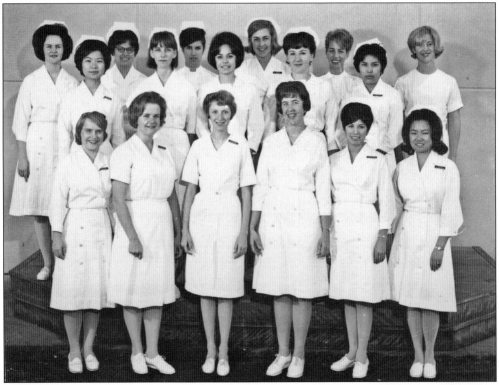

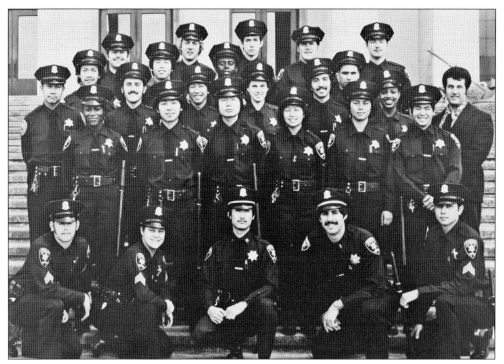

The first police program was established in the fall of 1939. Four decades later, Gerald DeGirolamo, a former CCSF student and later chief of police at the college, is pictured with the graduating class of 1978. Fred H. Lau, former San Francisco police chief (1996–2002) and the first Asian American to serve in that position, graduated from this program. (SFPL).

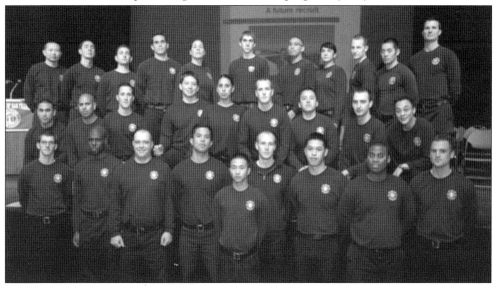

The first fire program was offered in the spring of 1940. Six decades later, members of the 2008 graduating class of the Fire Academy, located at CCSF's Airport Campus, are pictured here. Students who graduate earn the Educational Firefighter One Certificate and are eligible to work in any fire department in the country. Of the 29 graduates, three were accepted into the college's paramedic program at the John Adams Campus. (Courtesy of Jim Connors.)

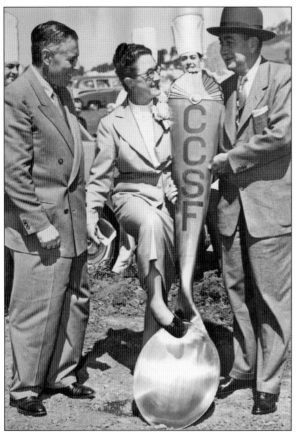

Dohrmann Hotel Supply Company provided the 5-foot stainless steel spoon pictured in this April 9, 1954, ground-breaking ceremony for a home for the Culinary Arts Department. President Conlan stands next to Hilda L. Watson, program director, and Albert Pick Jr., president of the American Hotel Association. Partially constructed with monies from the 1948 bond issue and dedicated on May 21, 1956, this building, below, named in honor of George D. Smith, general manager of the Mark Hopkins Hotel, housed kitchens, offices, classrooms, a student cafeteria, a large dining room with a soda fountain, and a separate faculty dining room. A bookstore and offices for the Associated Students were to be included, but because there was insufficient space for student representatives, in November 1955 two large bungalows were purchased and placed on Cloud Circle to accommodate them. (Left, SFPL; below, Menendez.)

This plaque is affixed to the wing adjoining Smith Hall on the east. It was funded in October 1961 by a $100,000 grant from the Ellsworth M. Statler Foundation with an additional $50,000 subscribed by hotels, restaurants, and related industries. The ground-breaking took place in February 1963. The centerpiece of the Statler Wing is the Alice Statler Library, a research source not only for the Culinary Arts Department but also for the public hospitality industry in the West. Dedicated on March 1, 1965, it was established by departmental alumni with matching funds from the Alice Statler Foundation. Mrs. Statler, dedicated to educating hotel and restaurant workers, was the widow of the late Ellsworth Statler, "the father of the American hotel industry." In the 1970s photograph below, Marion Mullaney stands behind the desk, ready to assist students, chefs, and hospitality industry professionals.

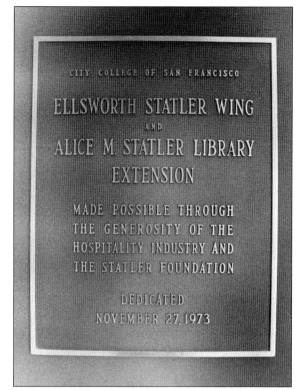

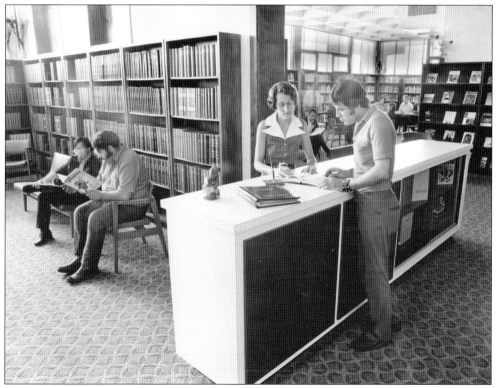

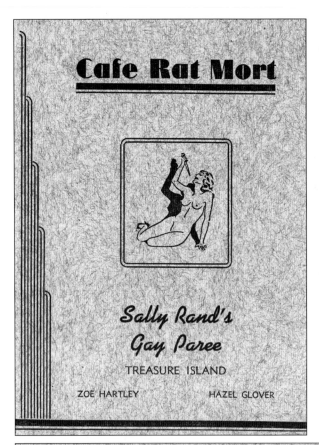

Cafe Rat Mort

Sally Rand's
Gay Paree

TREASURE ISLAND

ZOE HARTLEY HAZEL GLOVER

The Statler Menu Collection characterizes the culinary life of San Francisco and Northern California from 1920 to the present. It also contains menus from other states, railroads, cruise ships, and state dinners. The collection, including many rare items from the late 19th and early 20th centuries, began with the benefactions of the early librarians and alumni in the 1960s. In the 1980s, the menu collection was greatly augmented by a donation from the National Restaurant Association's Menu Design Awards competition. Pictured here is a menu for the Café Rat Mort at the Golden Gate International Exposition. It was associated with Sally Rand's nude ranch, a participant in the midway (Gay Way) at Treasure Island. Some 47 girls, dressed only in hats, bandannas, boots, and g-strings, engaged in various outdoor sports from 1:00 p.m. to 2:00 a.m. daily.

Special

French Dip Sandwich on French Roll ...25c

Hot Corned Beef Sandwich on Rye25c

Fried Ham and Melted Cheese25c

Fried Ham & Egg Sandwich25c

Cold Swiss or American Cheese on Rye ..20c

Cold Boiled Ham20c

Liverwurst Sandwich on Rye20c

Coffee when Served with Sandwich....... 5c

Regal Pale Beer with Sandwich15c

Cold Drinks

Regal Pale Beer20c

Coca Cola10c

Root Beer10c

Orange Crush10c

Milk10c

7-Up10c

Coffee10c

§

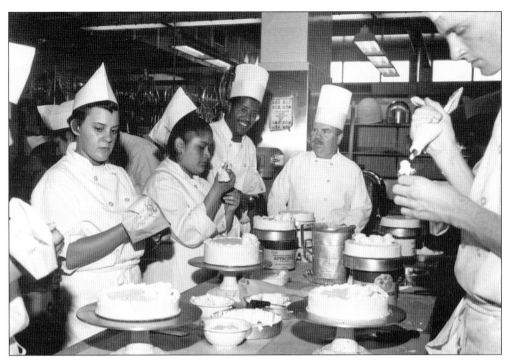

Culinary graduates learn all forms of food preparation, including baking, as seen in this photograph above of students decorating cakes under the watchful eye of their instructor. They also learn how to run a first class restaurant, the Pierre Coste Faculty Dining Room in Smith Hall. French-born Pierre M. Coste came to the United States in 1926 and was employed as chef at the Colony in New York City and other restaurants before moving to San Francisco to become the executive chef at the St. Francis Hotel, where he remained for 17 years. In 1948, he accepted a teaching position at the college, retiring in 1969. Below, faculty members, from left to right, Eloise Rivera, Valerie Mathes, Russell Posner, and Leon Luey are being served in the Pierre Coste Room.

Culinary students even seem to enjoy the hard work of cleaning pans, as pictured above. In the early years of the program, students learned practical skills as they assumed the operation of the cafeterias at both Marina and Everett Junior High Schools in 1937. At the Galileo High School cafeteria in 1939, lunches were 30¢, and "original chow mein" was served. On the Ocean Campus, students ran a soda fountain and a cafeteria in the basement of Science Hall. Today they practice their skills in the student cafeteria in Smith Hall. In the 1970s photograph below, with the menu prominently displayed on the back wall, students are waiting in line to purchase their lunch.

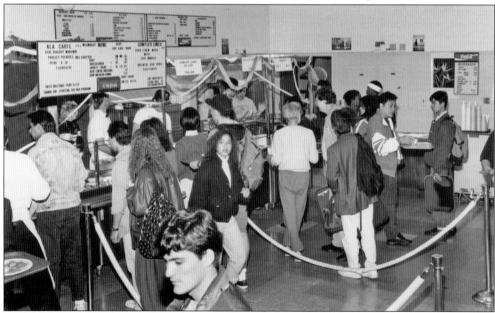

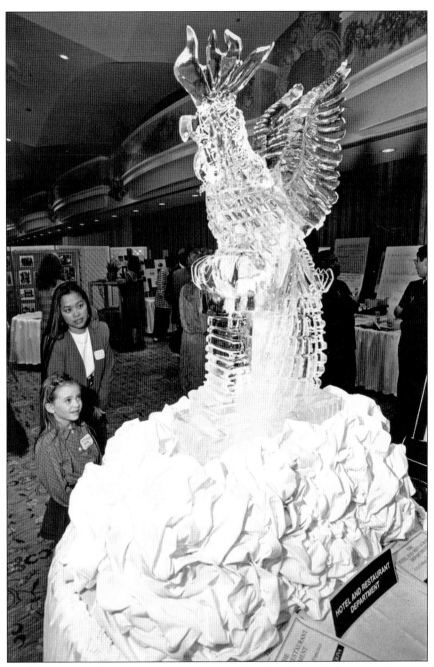

Because culinary arts students received extensive on-the-job training in hotels, clubs, restaurants, catering establishments, and airlines, beginning in 1940, graduates found employment with Pan American World Airways, serving on their Clipper ships during the 23-hour flight between San Francisco's Treasure Island and Honolulu, 3,000 miles away. Students checked luggage, served meals restaurant style, with snacks in between, and prepared bunks, as well as handed out reading material, beverages, pillows, and blankets for those who used lounge chairs for sleeping. Although Clipper ships no longer fly, students in the program still engage in interesting endeavors such as carving ice sculptures for special occasions, as seen here.

Established in 1964, Project FEAST (Food Education and Service Training) was designed to educate high school teachers, counselors, and administrators so they could teach food preparation programs at their own schools. In this 1971 photograph, Gene Atwood, a counselor from Tracy High School, holds a tray of salads. The program was a cooperative effort on part of CCSF, the California State Department of Education, and the U.S. Office of Education. (Bancroft.)

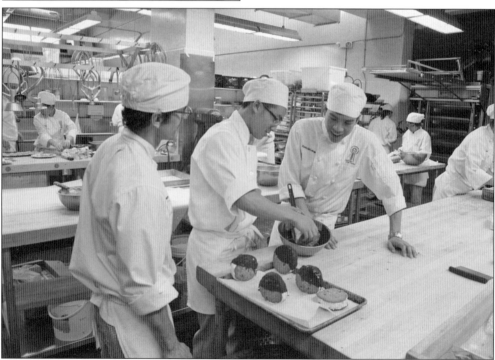

This 2009 photograph shows the Culinary Arts Department's spacious modern kitchen in Smith Hall. Michael Chung (center) coats ice cream sandwich cookies with chocolate as Tom Adamian (left) and Kevin Lacap watch. These desserts were later served in the student cafeteria. (Courtesy of Ramsey El-Qare.)

A successful bond election, Proposition A, in 1956, made it again possible for new construction. On May 26, 1959, President Conlan poses with a shovel during the ground-breaking for the $2,000,000 three-story Creative Arts building and Little Theater, designed to seat 350 people. Standing next to Conlan is Roberta Kennedy, college vice president, and Fred Muller, president of the Associated Students.

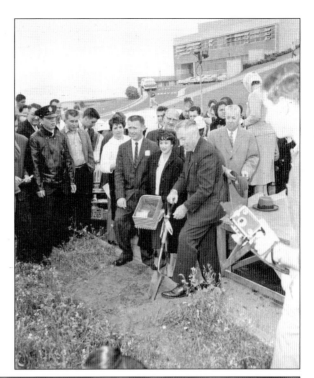

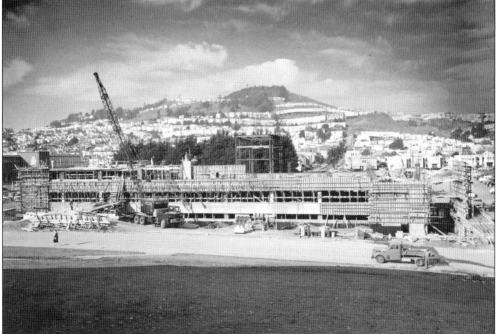

Under construction, the Creative Arts building, on the north side of Cloud Circle, was completed in February 1961. It provided classrooms for art and music and a state-of-the-art theater, equipped with an Izenour winch system for changing sets. The Drama Department could finally move from Science Hall 209 into a space that included a workshop and a remote controlled switchboard for lighting.

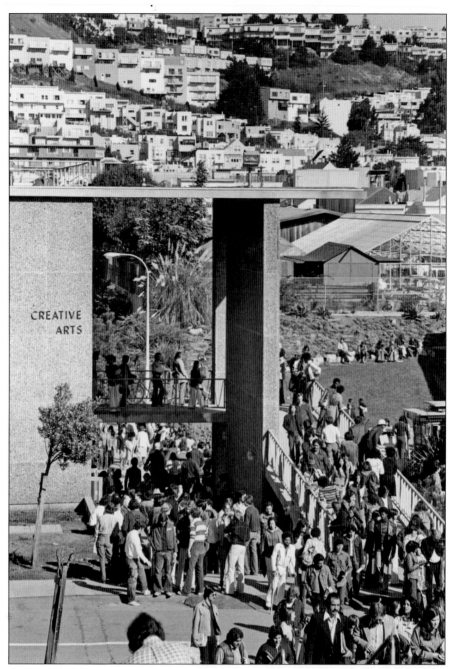

CREATIVE
ARTS

Students congregate in front of the Creative Arts building. Because of the orientation of the south and west classroom walls to conserve energy, this building won the American Institute of Architects Award in 1974. To the right, one can see the beginning of the Horticulture Department's greenhouses. In November 1970, to the west of this building, construction of a Creative Arts Extension was begun. Although President Conlan retired on August 31, 1970, he had clear oversight responsibilities for this new building, which was completed 20 months later at a cost of $1,511,000. It includes 20 classrooms, the television and radio studios, and music practice rooms.

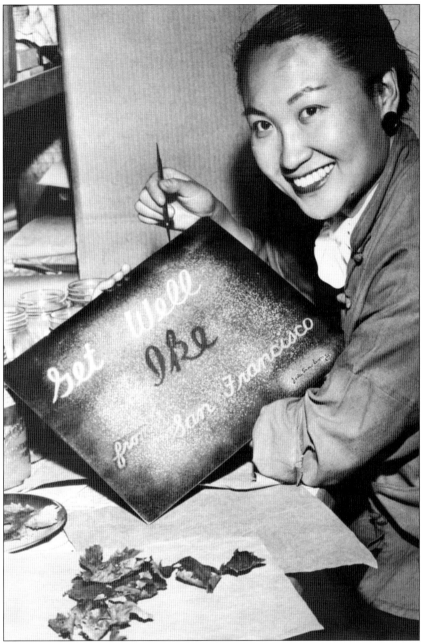

Jade Snow Wong, art student and salutatorian of the 1940 class, poses with a "Get Well Ike" card for the ailing president of the United States. Wong, later a well-known ceramist, wrote *Fifth Chinese Daughter* (1945) telling her childhood in San Francisco's Chinatown. A Book-of-the-Month Club selection in 1950, the book has been reprinted in various languages. In 1948, she was chosen by *Mademoiselle* as one of the top 10 young women of the year. Her second book, *No Chinese Stranger*, was published in 1975. Two decades later, Steve Silver, producer and director of *Beach Blanket Babylon*, sang the praises of the college's art department. "The things I did at City College in my art classes were instrumental in the design of the hats for the show. I learned so much there." (SFPL.)

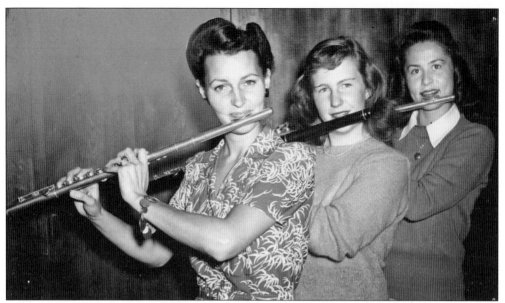

In September 1935, President Cloud established an a cappella choir under the direction of Flossita Badger, the Music Department chair. The choir's biggest events were the annual Spring Concert and the Christmas Festival. With Badger directing and Madison Devlin conducting the orchestra, this flute trio of Suzanne Greenfield, Claire Bonner, and Barbara Stephen performed a sonata by James Hook and *Allegro Giocoso* by Richard Haydn at the WAVES auditorium during the 1945 Christmas holidays.

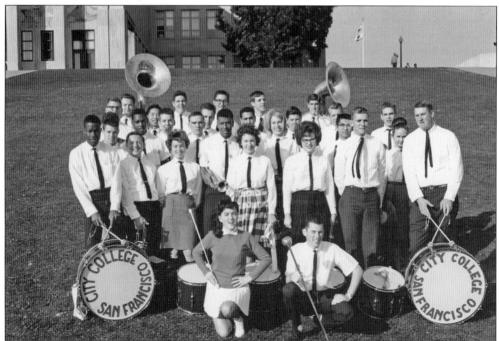

During the early 1960s, the CCSF marching band poses on the lawn on the south side of Science Hall with one of Herman Volz's murals in the background. During the fall, the band played at pep rallies and during the spring performed concerts.

In the 1970s, a student broadcasts over the campus radio station KCSF (Cable 90.9 FM) or "The Zone." On the wall are rules for student announcers, reminding them to identify the station every half hour, begin and end on time, and avoid dead air. Today this student-run station broadcasts 24 hours a day over the internet via Comcast cable radio. "The Zone" is part of the academic program in the Broadcast Electronic Media Arts Department, which has classes in video production, radio station operations, sound design, and broadcast journalism. Graduates include Nick DeLuca, public affairs director of KCBS; Peter Borg, former news director at KQED; Tony Sandoval of KISS; Renee Richardson of KFOG; Stan Burford of KGO; 2007 Bay Area Radio Hall of Fame winner, Carter B. Smith, who worked at KABL; and Emmy Award winning anchorwoman, Cheryl Jennings at ABC 7 News.

Today's successful horticultural program, founded in the fall of 1938, grew from a formal request by the cut flower and seed industry in San Francisco. Initially students were trained twice a week at the Hallawell Seed Company nursery. At that time, the department only had an inadequate greenhouse on the roof of Science Hall and use of a greenhouse at 23rd Avenue and Quintara Street. In 1947, a new center with two classrooms, office space, tool room, large lath house, two small lath houses, and three greenhouses was built to the south of the men's gym. Within three years, students had planted over three acres. In the top photograph, students and instructors are gathered in front of the building in the late 1940s, while in the second photograph, students are seen potting plants in the department's greenhouse in the 1950s.

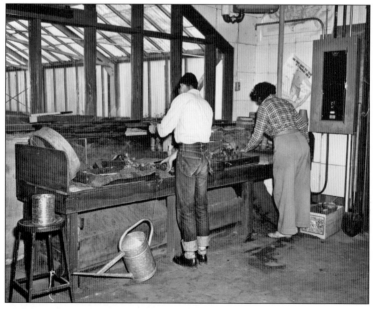

On March 26, 1963, the ground-breaking took place for the new horticultural center adjacent to Judson Avenue with monies from the state and the 1956 district school bond. It replaced the old center, begun in March 1947, but later torn down to make way for the construction of a new roadway, San Jose Boulevard and Highway 280, a short distance behind the gyms. Formally dedicated in April 1964, this ranch-style building, pictured above, includes a flower shop, walk-in refrigerator, a library, a laboratory, four heated glass greenhouses, and two lath houses. In the 1960s photograph of the flower shop to the right, a customer is buying a bunch of daffodils from a departmental student. (Above, Menendez.)

The two-story Educational Services building, pictured above on the corner of Ocean and Phelan Avenues, was begun in February 1967 using monies from the successful passage of Proposition B in November 1964. Completed in the spring of 1968, the building includes offices for counselors, a registration office, a larger bookstore, administrative offices, and a large lecture hall. It was named in honor of Dr. Louis G. Conlan, a member of the original faculty who served as college president from 1949 to 1970 and then temporarily as the first president/chancellor of the newly organized San Francisco Community College District. Although in the older photograph below the counselor seen advising a student in 1951 was not actually working in Conlan Hall, similar duties are performed today in the building. (Above, Menendez.)

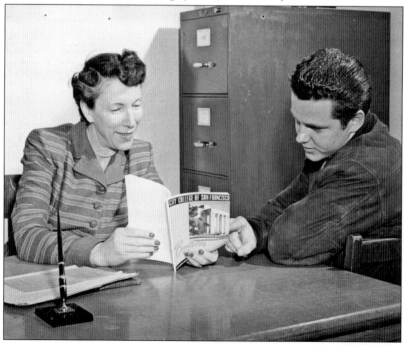

Using remaining funds from City Proposition B, the ground-breaking for the 34,000-square-foot Visual Arts building, east of the Creative Arts building, took place on May 28, 1968. The one-story building, costing $1,188,500, was completed in the spring of 1970 and houses laboratories for the Photography Department, Graphic Arts, and Printing Technology. Also included are classrooms and two theater-lecture rooms. In the 1970s, a crowd of students is streaming past the Visual Arts building up the steps toward Science Hall and Cloud Hall. Greenhouses can be seen in the background as well as the ramp up to the Creative Arts building to the left.

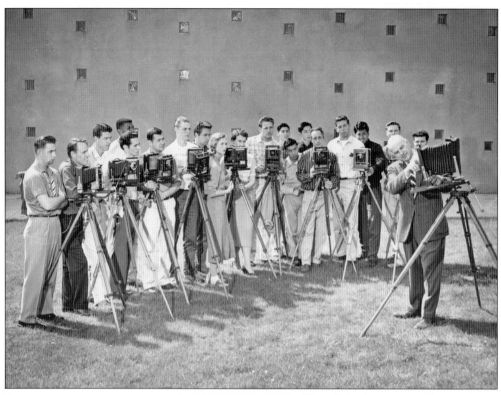

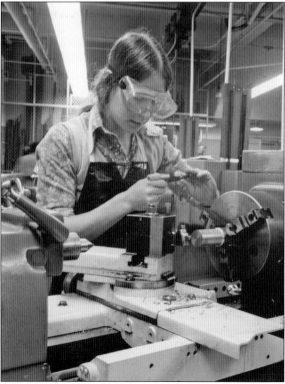

Two of the departments housed in the Visual Arts building are photography and Printing Technology. In the photograph above, students gather in front of Smith Hall around their instructor, Beverly Joseph Pasqualetti, who is credited with founding the Photography Department, one of the first such academic departments in the western United States, and today one of the oldest and largest programs in the country. The Visual Arts building has four spacious shooting bays equipped with lighting facilities and everything else the professional, fine artist, student, or amateur enthusiast needs. Outstanding student artwork is showcased in revolving exhibits in the Gallery Obscura. In the photograph at left, Lainie Levick is shown in the Printing Technology lab. Originally appearing in the 1948–1949 catalog as the Graphic Arts Program, by 1958 it had become Printing Technology.

Located next to Smith Hall, this three-story Student Union building begun in 1969 includes offices for the Associated Students, space for the Student Council Chamber, an auditorium, lounges, a café, and recreational space. The last structure to be completed prior to President Conlan's retirement, it was not financed by the college but by a loan from the U.S. Department of Housing and Urban Development. (Menendez.)

Located on the north wall of the Student Union building, this mural, entitled *Song of the Spirit*, depicts the cultural diversity of the college. Conceived as a protest to Proposition 209, which removed the state affirmative action requirement, it was designed by students under the direction of Susan Cervantes of Precita Eyes Mural Arts of San Francisco. Part of this mural is visible to the right of the entrance to the building. (Menendez.)

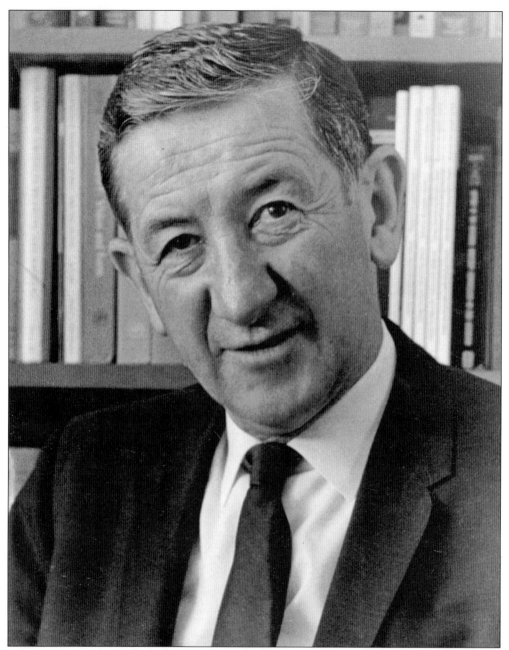

Dr. Louis F. Batmale, a graduate of Lowell High School, attended the University of San Francisco, where he was a basketball star. After receiving a master's degree and an Ed.D. at the University of California, Berkeley, he taught French and history and coached the basketball team at Galileo High School before entering the navy. In 1947, he came to CCSF as a veterans' counselor. Appointed chancellor of the newly created Community College District, he was given the responsibility of organizing the college centers (today designated as campuses) by the fall of 1970. He retired in 1977 after a 37-year career at the college. In 1979, a new academic building on Cloud Circle was named in his honor. In 2001, the San Francisco Forum honored him as "San Franciscan of the Year."

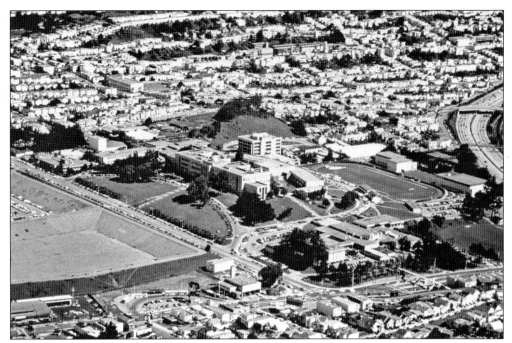

This aerial photograph of the campus clearly shows the multistoried Batmale Hall in the center, behind Cloud Hall and Science Hall. This seven-story office and classroom building, designed by Milton Pflueger's son John, was begun in 1974 and dedicated on May 24, 1979. Constructed with three stories below ground, this building, which cost $7,891,000, has interior classrooms, 10 laboratories, and faculty offices. Because of the lack of money, the originally planned exterior tiling was never completed. There was no further construction on the campus for the next 14 years. The empty Balboa reservoir basin on the bottom left became the battleground for the completion of the campus. The photograph below shows the Louise and Claude Rosenberg Jr. Library and Learning Resource Center, one of Timothy's Pflueger's original dreams. It opened in December 1995 at a cost of $25.5 million, funded by the State of California. (Below, Menendez.)

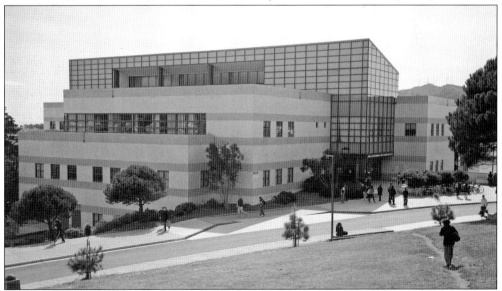

The Architects Collaborative, one of the most respected architectural firms in the world, designed the library. It was established by Bauhaus founder, Walter Gropius, in Germany in 1925. The principal architect of the Rosenberg Library was James Burlage, who incorporated rounded forms and curves into the Bauhaus design. This interior photograph showcases the Madeleine Haas Russell Atrium, which is used for rotating exhibitions on three floors. On the right, one can see a unique sculptural installation of blown glass spheres by Ann Carter titled *Constellation*. In the 1999 aerial view below, the rounded Bauhaus style is visible. Also seen are the new track, football field, stadium seating, and press box. San Franciscans funded this athletic facility upgrade via a Maintenance Assessment District tax. (Left, Menendez; below, courtesy of Ken Gray.)

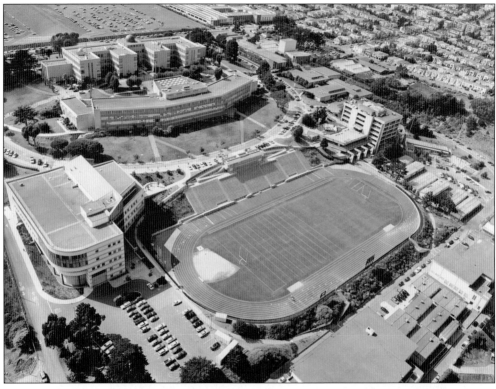

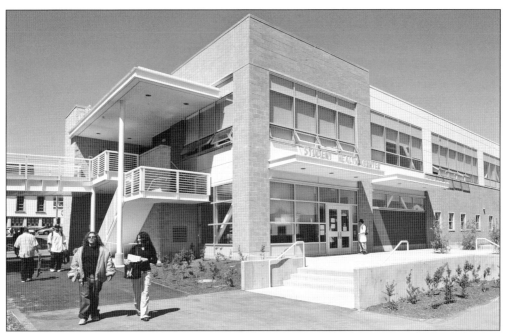

The Student Health Center on the corner of Phelan and Judson Avenues, pictured above, was completed in June 2006. Below, Dr. Philip R. Day Jr., CCSF chancellor, stands next to Nancy Pelosi, then a California congresswoman and now Speaker of the House of Representatives. Pelosi secured $750,000 in federal funds for furniture and equipment for the building. The banner behind them celebrates yet another successful local bond measure. The center, which serves over 20,000 students annually, has consultation and treatment rooms on the first floor and 10 classrooms on the second. The professional medical staff provides students and faculty with general medical needs, and other services such as psychological counseling, eye examinations, and HIV counseling and testing. (Above, Davey; below, courtesy of Tanisha Higgins.)

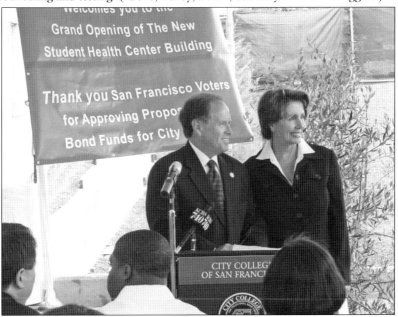

The new Orfalea Family Center for Child Development and Family Studies, pictured above, opened in 2008. The center, which serves as a laboratory for classroom learning, provides quality childcare at the Ocean Campus. The facility is named in honor of Paul Orfalea and his wife, Natalie, below, founders of Kinko's Copy Shop, who provided the college in 2001 with a 10-year $8.5 million grant to make CCSF a model for childcare in America. The Family Studies Department also offers day care at the Mission and John Adams campuses and at three community-based locations. Credit classes leading to an associate in arts degree for child development professionals are offered as well as non-credit classes for parents and guardians. (Above, Herman; left, Davey.)

The center consists of four buildings, like the one pictured above, with living roofs. The administrative offices include a kitchen area, a lactation room for use by both employees and student parents, office and staff space, and a classroom. Toddlers are served in a separate building with a play yard for younger children, and preschoolers are located in a larger area. Below, preschoolers play in front of a Peter VandenBerge mural of ceramic relief glazed tiles depicting animal and plant life in vibrant colors. When the San Francisco Art Commission was unable to locate an appropriate playground location for the mural, it was offered to CCSF and was displayed at the south end of the library reading room in Cloud Hall. Following construction of the Rosenberg Library, the mural was stored until installed at the Orfalea Center in 2008. (Above, Menendez; below, courtesy of Judith Hearst.)

Seen from Ocean Avenue, the three-level Community Health and Wellness Center, above, financed by bond measures in 2001 and 2005, opened in the spring of 2008. The broad lawn area in the foreground will soon be home to Robert Howard's *Whale Fountain*, on permanent loan from the San Francisco Art Commission. The wellness center consolidates the physical education programs of both the men's and women's athletic departments. The building includes a weight room, fitness center, facilities for team athletics, studios for dance, aerobics, and martial arts, and a 25-meter indoor swimming pool, pictured below. It has taken more than 70 years to build the pool—part of Timothy Pflueger's original vision. (Both, Menendez.)

The college offers traditional physical education classes, as well as courses such as this 1973 fitness-through-walking class held on Saturdays. Tour leaders took students on a 4-to-5-mile walk through various San Francisco neighborhoods. They are pictured here before a San Francisco Victorian on Walk Number Four through the Haight-Ashbury.

In 2007, the Isadora Duncan Dance Awards Committee presented its "Izzy" award to the college's dance program for 70 years of excellence in instruction and performance. Pictured are, from left to right, Luana, Coni Staff, Martha Lucey, Dan Hayes, Dr. Anita Grier, Gail Barton, Lene Johnson, Susan Shuey, and Kathe Burick. (Davey.)

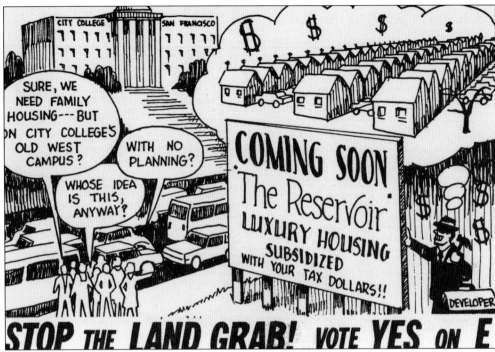

In late 1985, CCSF learned that City Hall proposed selling 12.3 acres of the Balboa Reservoir to a private developer for $36,900. This land, once part of the West Campus, was always considered to be included in the original master plan for the completion of the campus. The faculty collected voters' signatures to put Proposition E on the June 1986 ballot and asked for a yes vote. CCSF lost. (Courtesy of Paul Hewitt.)

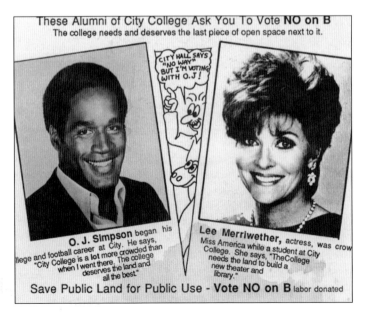

In spite of a strong showing of support, the college needed a second measure, Proposition B, to clear the rights to the land for the completion of the college. In 1987, faculty, staff, students, and alumni collected 24,752 signatures in less than 30 days. The measure asked for a "no" vote to rezoning for single-family homes. The voters and prominent alumni reaffirmed their support for needed college facilities, including a library and a performing arts center. CCSF won.

In 1988, City Hall responded to this victory by placing the same issue back on the ballot with just the mayor's signature. The "L No" campaign was intense and included a midnight trip into the south reservoir where this compelling message to the voters was painted. The entire college community united in this grassroots effort against a private developer, big money, and the political machinery of San Francisco. CCSF won.

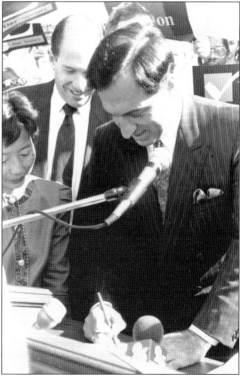

After a fourth vote related to reservoir zoning, which would have been unfavorable to CCSF, a second Proposition L measure was again defeated. In 1991, Chancellor Evan Dobelle and Mabel Teng, trustee, watch as Mayor Art Agnos signs over the 12.3 acres. CCSF could finally proceed with planning and budgeting for the completion of its main campus as well as considering the facilities needs of the entire district.

The almost-completed Multi Use Building, pictured here, is the first 21st century building on the former West Campus. It will include classrooms for programs in teacher preparation and certificated health care professions. It will also contain various student services offices, faculty offices, and a café. (Menendez)

The new Performing Arts Center, with a 650-seat auditorium, a black box theater, a 150-seat recital hall, rehearsal and practice rooms, and faculty offices is planned for the West Campus. Designed by the architectural firm of Tom Eliot Fisch/LMN, it earned an Award of Merit in November 2008 and received a national award for its sustainable design. Its completion will fulfill the Cloud and Pflueger master plan for the main campus.

Five

CREATION OF THE SAN FRANCISCO COMMUNITY COLLEGE DISTRICT

In 1970, CCSF separated from the Unified School District, taking with it their adult and occupational courses. Soon non-credit programs were held in over 250 locations in public schools, churches, storefronts, libraries, and office buildings in this community college without walls. The former Radio Corporation of America production facility at 33 Gough Street, pictured here, was purchased as district headquarters and renovated. It also houses the Teacher Resource Center for ESL faculty.

This woodcut celebrates a 1939 course in aeronautics, jointly sponsored by the college and the Civil Aeronautics Authority and designed to provide increased aerial strength for the country. Graduates were qualified to fly airplanes for national defense. Helen Crlenkovich, the college's diving champion, was the only woman in the program; her coach for her solo flight was also a woman, instructor Janet Knight. Helen received her pilot's license in 1941.

The Airport Campus at the San Francisco International Airport houses the Aircraft Maintenance Technology Program. Originally at John O'Connell Vocational School, it was moved in 1970 to the old Pan American Terminal. In 1976, the college district, the Flying Tiger Line, and the San Francisco Airport Commission partnered to build a one-story prefabricated steel structure housing a large hangar, six classrooms, seven shop instruction areas, a student commons, and an audiovisual center. (Davey.)

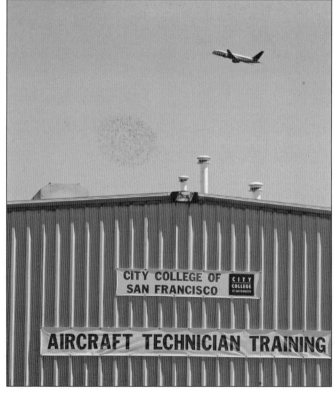

By 1976, the fleet of planes owned by CCSF included two helicopters, one Navion, a Cessna 310, and a T-33 jet aircraft. Pictured above, with City College of San Francisco written on its side, is the plane donated to the program by United Airlines. In the photograph below, with a small plane in the background, two students are shown, one changing a tire, the other taking notes. (Below, courtesy of Rick Gerharter.)

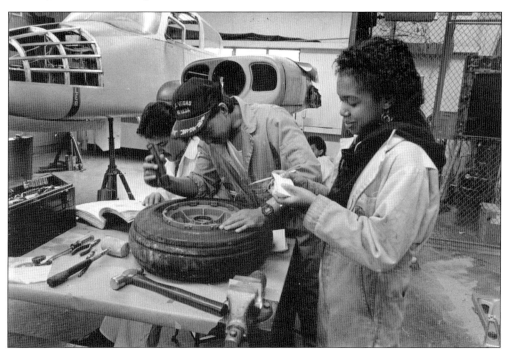

QUEER STUDIES

THE ONLY
DEPARTMENT OF
GAY, LESBIAN & BISEXUAL
STUDIES IN AMERICA

CITY
COLLEGE
OF SAN FRANCISCO

CITY COLLEGE OF SAN FRANCISCO

Castro/Valencia Campus
450 Church Street
San Francisco, California 94114

In the early 1970s, a gay literature course was team-taught by members of the English Department. This course, English 55 (Gay Literature), and Film 120 (Homosexuals in Film) evolved on the Ocean Campus into a full academic department in 1989, the first in the country, devoted to gay, lesbian, and bisexual studies.

A Campus for the Community
with
A World of Course Offerings

french
russian
japanese
spanish
italian
chinese german

CITY
COLLEGE
OF SAN FRANCISCO

Spring 2001 Schedule
Classes start January 17, 2001

Castro/Valencia Campus
1220 Noe Street at 25th Street
in James Lick Middle School

This brochure from 2001 reflects the "world of course offerings" at what eventually would become the Castro/Valencia Campus. It was initially started as a small, specialized non-credit evening program in the early 1980s focusing on gay and lesbian programs with courses offered at multiple locations. The non-credit courses relate to parenting and relationship issues.

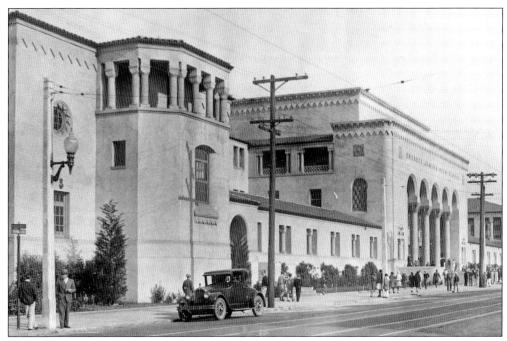

Since the summer of 2009, evening classes have returned to Everett Middle School at Seventeenth and Church Streets, pictured here in the summer of 1928. This campus has the third highest credit enrollment of all CCSF campuses. Course offerings are now widely diversified, with foreign languages, arts, English, humanities, behavioral and social sciences, and physical education. Only five percent of the courses are in gay, lesbian, and bisexual studies. (SFPL.)

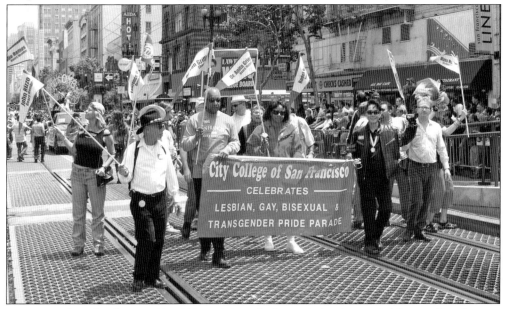

CCSF turned out for the June 29, 2008, Pride Parade down Market Street. Holding a college banner celebrating gay pride, from left to right are administrator Stephen Herman, interim chancellor Dr. Don Q. Griffin—the first chancellor to participate in this parade, trustees Dr. Anita Grier and Lawrence Wong, and classified staff member James Rogers. (Courtesy of Lancelot Kao.)

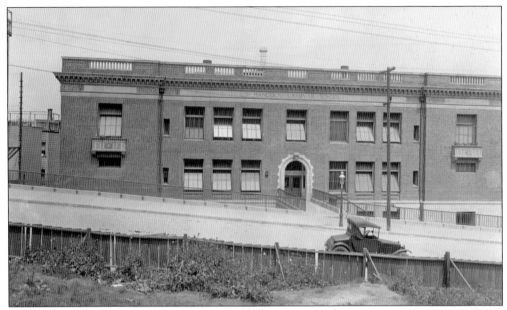

The college has focused on serving the Chinese community since the early 1970s, beginning with an outreach program of the Civic Center (Alemany) Campus. Currently over 6,000 students are educated in eight leased facilities throughout Chinatown, North Beach, and in the Marina District with the John Hancock Grammar School at 940 Filbert Street serving as the main classroom facility, shown above in this early photograph. The picture below documents the ribbon-cutting ceremony for the main Chinatown/North Beach Campus in 1981. From left to right are, (first row) Julie Tang, Willie Kennedy, Lillian Sing, John Yehall Chin, Francis Lee; (second row) Dr. Tim Wolfred and Bill Maher. Tang, Sing, and Wolfred at the time were members of the college's board of trustees, and Kennedy and Maher were San Francisco supervisors. (Above, SFPL.)

This student body is primarily Asian/Pacific Islander and over 40 years old. Although ESL and citizenship classes make up the major part of the offerings, classes in home health aide training, computer studies, accounting, child development, and vocational ESL classes called Food Service, Chinese Cooks, and Restaurant Workers are also available. The campus headquarters has appeared in two movies, the car chase in *Bullitt* and *Mrs. Doubtfire*.

At an October 17, 2007, press conference called by the Friends of Educational Opportunities, San Francisco mayor Gavin Newsom declared his support for a comprehensive Chinatown/North Beach Campus to be constructed on the corner of Kearny and Washington Streets. Chancellor Philip R. Day Jr., center, addresses trustees, the mayor, and other officials. Funding will be provided by two local bond measures, with matching state funds. Construction began in February 2010. (Davey.)

The Civic Center Campus, formerly Alemany, occupies this three-story red brick building at 750 Eddy Street. The interior reflects its earlier life as an elementary school, with low water fountains and long cloakrooms. The campus, named after Bishop Joseph Sadoc Alemany, is devoted to free non-credit ESL classes. Alemany, founder of St. Mary's College, is credited with establishing the first adult English instruction in 1856 to San Francisco newcomers, Gaelic speakers from Ireland.

Penny Larson, who trained Malaysian teachers when she was in the Peace Corps, is pictured in 1976 teaching a group of ESL 100 students at the then Alemany Community College Center. Today most students on this campus are from Vietnam and China, although Russian and Latino students join those from Laos and the Philippines.

English classes still remain crucial for the 3,000 students at this campus as seen by their participation in this 2009 demonstration at the Civic Center against state budget cuts in education. During the late 1960s, texts, methodology, and materials for ESL were developed at this campus. Classes are also taught in citizenship, computer use, and GED preparation.

Civic Center Campus supervisor Michael Nguyen, staff member Sunny Ngo, and student Huong Dinh participate in distributing CCSF information at the Tet Festival celebrating the Vietnamese New Year. Their Eddy Street campus was transformed into a high school for the movie *Sister Act II*, starring Whoopi Goldberg with the neighboring Hotel Le Nain becoming the convent. (Courtesy of Gary Tom.)

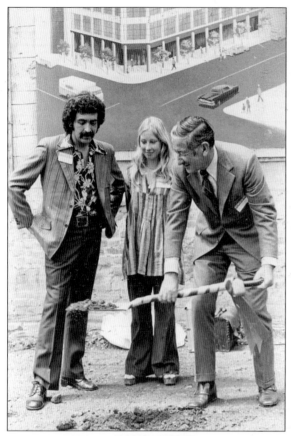

With architectural plans prominently displayed in the background, Dr. Louis F. Batmale, CCSF chancellor, pictured left, displays the first shovelful of dirt in this ground-breaking ceremony for the Downtown Campus at Fourth and Mission Streets. The eight-story Downtown Campus, below, began in 1975 at the cost of $9,163,500 and opened in 1979, offering 300 classes during the first semester. Recently renovated, the facility consists of 43 classrooms, six teaching labs, a library, a television and audiovisual distribution system, a training kitchen, and dining rooms as well as administrative offices. Its Office of Contract Education provides services for public, private, or community organizations to customize a training program for their employees. (Below, Herman.)

The Educated Palate Dining Room is the training program for the Culinary and Service Skills Training Program at the Downtown Campus. First semester students learn how to manage the dining room, while second semester students prepare the food for the restaurant and adjoining café. This program is non-credit and offers more hands-on training in cooking and service than the similar program at the Ocean Campus and is tuition free. Chuluunchimeg Lkhamsuren, above, and her classmates in Food Technology and Dining Service enjoy serving a full house in the recently relocated restaurant, with its sunlit interior and floor-to-ceiling windows. Below, management instructor Christopher Johnson, center, poses with his students. (Above, courtesy of Christopher Johnson; below, Chao Jun Feng.)

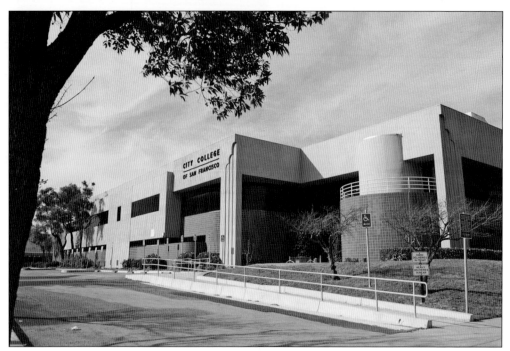

Although teaching at the Evans Campus began in 1994, the district did not purchase this building at 1400 Evans Avenue until 2001. This is CCSF's School of Applied Science and Technology, founded to meet the demands of the 21st century workplace. Classes are offered in automotive and motorcycle technology, and building maintenance, with workshops in solar technology, biodiesel and alternative fuel, forklift training, and geographic information systems. (Menendez.)

Art at Evans includes a replica of the Rivera mural, photographs by Joe Blum, documenting the building of the new east span of the Bay Bridge, and the *Our Work, Our Life* mural telling the story of the working people of the Bay Area. Part of that mural, a collaborative effort of Oscar Melara, CCSF librarian Kate Connell, and the Labor Archives and Research Center at San Francisco State University, is shown here. (Courtesy of Kate Connell.)

Students and instructor Fred Hansen are inspecting the engine of an automobile when the automotive program was at the John O'Connell location. Now this program is offered at the Evans Campus.

Lisa Duke, an instructor in motorcycle technology, poses with several students in this 2009 photograph. In the spring of 2002, the Evans Campus became the first Bay Area community college to offer a motorcycle maintenance course with hands-on lectures and guidance. To earn a motorcycle training degree, students must complete 34 units of technical training as well as general education courses. Duke herself is a graduate of this program. (Courtesy of Lisa Duke.)

Fort Mason, situated on the north shore of San Francisco facing the bay, is the location of CCSF's Art Center at 1840 Laguna Street. The center, with faculty drawn from the college's art department, offers credit and non-credit and day and evening classes in art, ceramics, sculpture, drawing, painting, photography, and printmaking, as well as classes in continuing education. A popular art sale is held every December to generate funds for the program. (Herman.)

In this 1977 photograph, Beth Goodsitt is sculpting her unicorn, which she said had "been in her head for two years." She and many other students at Fort Mason were making items to sell at the Christmas art show. These continuing education art classes allow Goodsitt and other city residents the opportunity to develop their creative and artistic interests.

Shown right, the former Lowell High School at Masonic and Hayes Streets was built in 1911. The last graduating class was in 1962, and in 1971 the facility joined the district as the John Adams Campus. Following recent renovation, the historic brick building now includes 64 classrooms and labs; an auditorium; a state-of-the-art childcare center; and library and offices for counseling and administrative services. Both credit and non-credit courses and programs are offered days, evenings, and on Saturdays in business/office technology, child development and family studies, disabled students program and services, ESL, health care technology, transitional studies, and vocational nursing. Below, vocational nursing instructor Ellen Bergman stands with her students before they begin their clinical experience. (Below, courtesy of Julia Bergman.)

A mural entitled *Our History Is No Mystery* was painted on the retaining wall on the corner of Masonic and Hayes Streets in 1976 by Haight-Ashbury muralists. In 1988, the same artists redesigned, restored, and repainted the mural, and it was renamed *Educate to Liberate*. In 2006, Mary Marsh and Maria Pinedo, two John Adams library technicians, assisted with the creation of a new mural, *Educate to Liberate: Lessons in Community*. (Menendez.)

Between 2006 and 2009, funded by local bond measures, the building underwent major seismic upgrading and renovation. The only part of the building to escape the contractor's hammer was the storage annex. On February 29, 2010, the ribbon-cutting ceremony included lion dancers and music. The event was celebrated by Linda Squires-Grohe, dean; Carmen Roman-Murray, trustee; Dr. Natalie Berg; Ross Mirkarimi, supervisor; Dr. Don Q. Griffin, chancellor; and John Rizzo, trustee. (Menendez.)

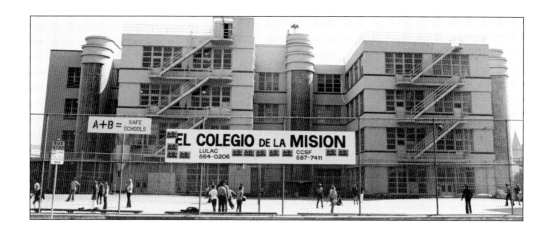

The Mission Campus at 1125 Valencia Street has been meeting the needs of city residents since 1971. The former Samuel Gompers School, above, was renovated and reopened in 2008, along with a new four-story building, below, with its Aztec sun calendar of ceramic tile. Newly wired classrooms and labs, an auditorium/theater, offices, multipurpose rooms, and a new Child Development Center on the ground floor better serve local residents. Journalism and Broadcast Media Arts are on the second floor with the Transitional Studies Center, biotechnology, science, and ESL classrooms on the third. The top floor houses a 7,200-square-foot library. More than 8,000 students, 68 percent of whom are Latino, take classes. Construction of the new building, boldly clad with recycled tile, was financed by 2001 and 2005 bond measures with matching state funds of $30 million. (Below, Herman.)

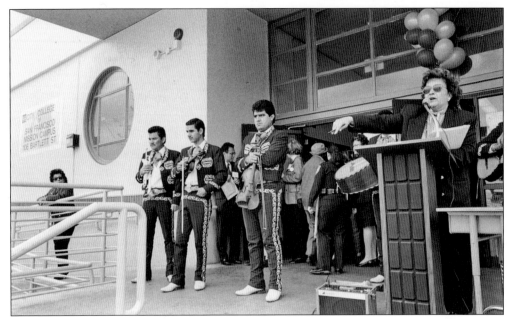

Mariachi bands have historically been included in ceremonies and celebrations at the Mission Campus. The photograph above shows Dr. Carlota Del Portillo, campus dean, at the podium while the band waits to perform. After 30 years of planning, the new Mission Campus officially opened in February 2008, once again with mariachi music. Many dignitaries joined Chancellor Philip R. Day Jr. in praising the new campus. In the photograph below, some of the celebrants, Dr. Del Portillo, several college trustees, Mayor Gavin Newsom, and Speaker of the House Nancy Pelosi, are joining hands in the ribbon-cutting ceremony. (Above, courtesy of Joyce Benna; below, Davey.)

The Southeast Campus, pictured here, opened in 1987 at 1800 Oakdale Avenue at Phelps Street and serves the Bayview, Hunter's Point, Visitation Valley, and Potrero Hill communities. The building, owned by the city and built as a community "mitigation" facility, is required by law to include an educational program. A broad range of programs is offered, including the Bridge to Biotech and the Green Career Internship Programs, which orient students toward green careers. (Menendez.)

During CCSF's 70th anniversary in 2005, San Francisco mayor Gavin Newsom (left) presents a proclamation highlighting the campus stem cell program to Dr. Veronica Hunnicutt, Southeast Campus dean. Next to the dean are Johnnie L. Carter Jr. and Dr. Anita Grier, CCSF trustees, and Dr. Philip R. Day Jr., chancellor. (Davey.)

The Southeast Campus is also home to Mayor Newsom's Gateway to College program, begun in August 2009. The program enables dropouts to complete their high school graduation requirements while earning college credit toward an associate in arts degree or certificate of completion. Pictured above is a press conference in August 2009 launching this new program. Among the guests and dignitaries are Dr. Veronica Hunnicutt, campus dean; and Dr. Don Q. Griffin, chancellor. (Davey.)

Audley and Josephine Cole are seen here in the Southeast library, named in Josephine's honor in 1992. Audley Cole was the first African American hired by San Francisco MUNI (1942), and his wife was the first African American teacher hired by the San Francisco Unified School District (1942). In 1995, the San Francisco Board of Supervisors chose her the "Outstanding Community Leader" of San Francisco. (Courtesy of the Josephine Cole Library)

Six

STUDENT ACTIVITIES

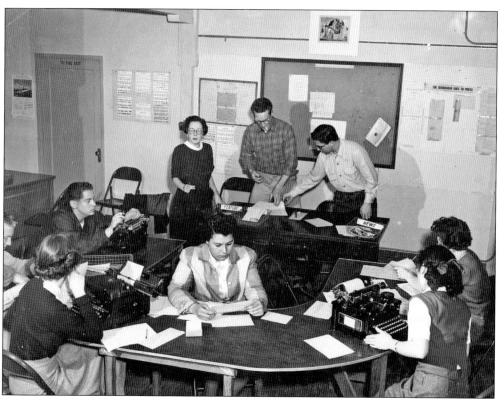

The staff of *The Guardsman* used the ruins of the old jail as headquarters, hoping to convince school authorities of their need for a proper workspace. When Science Hall was completed, they were given offices on the first floor. Joan Nourse, *The Guardsman*'s faculty advisor for 33 years and a charter member of the college is pictured here with the paper's staff.

To set standards, President Cloud had the first issue of the paper written in 1935 by faculty advisors, Lloyd Luckman and Francis Colligan. By 1939, *The Guardsman* had received an All-American rating from the Associated Collegiate Press (ACP). Then during the next 16 semesters of membership, it won 14 times. A *Guardsman* reporter, pictured left, is typing copy. One of many graduates of the journalism department was Jerry Flamm, author and reporter for the *San Francisco Call Bulletin*.

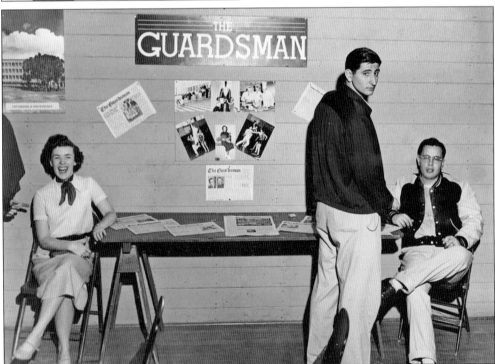

Staff members are shown in this 1950s photograph. By the spring of 1957, the paper had received its 27th All-American ACP honor rating. In the regional conference of the Journalism Association of Community Colleges (JACC) in November 2009, competing against 22 Northern California colleges, *The Guardsman* took home 20 awards. It has won the JACC Pacesetter Award in 1998, 2005, 2009, and the association's General Excellence Award 13 times since 1997.

To create a sense of collegiate identity, President Cloud used latent rivalries between the freshmen and sophomore classes to encourage them to participate in a semiannual "frosh-soph brawl." Activities included playing basketball wearing boxing gloves, seven-legged races, fights with eggs taped to each man's head while the other tried to break them with a towel, and a tug-of-war using fire hoses as seen above in this 1936 photograph. Another activity was wrestling in a large mud hole as viewed in this January 1938 photograph below. Classes were cancelled for the day, and female students supported their team. This ritual "brawl" did not survive the college's move to the permanent campus in August 1940. (SFPL.)

Part of the college experience is the obligatory trip to the college bookstore for texts, stationary, pens, binders, and other essentials. Before the Ocean Campus was built, the bookstore was at 518 Powell Street as seen in this August 24, 1938, advertisement in *The Guardsman*, offering all necessary supplies and advertising that the bookstore bought back old textbooks at the highest cash price. Students did not agree and consistently criticized the privately owned bookstore for charging high prices and failing on occasion to refund money for books purchased for classes that were dropped or cancelled. In the 1952 photograph below, students are perusing the campus bookstore, which by this time was a cooperative. (SFPL.)

This diagram, which governed clubs, regulated the college social life. From the class of 1948, Allen E. Broussard, later an associate justice on the California Supreme Court, wrote that his participation on the Student Council and the Club Advisory Board was as important as his academic studies. There were numerous clubs to advise, including social groups such as fraternities and sororities and academic groups such as Alpha Gamma Sigma, the service honor society, and a riding club, which held horse shows. Departments sponsored groups such as the Debating Society and the College Band Club. There was the Ram Cam for photographers; the Strikes and Spares for bowlers; various athletic organizations including the Women's Athletic Association; and Block SF, composed of athletes who had won their college letters. Pictured below, with faculty advisors, are members of the 1957 California Junior College Student Government Association.

GET BIDS NOW

For

THE SOPH FORMAL

DECEMBER 3RD

At

THE GOLD BALLROOM

Of The

PALACE HOTEL

President Archibald Cloud encouraged the officers of the Student Association to sponsor pep rallies, musical presentations, and organize trips to football games played away from home. In addition, there were homecoming activities, home football games, a best-dressed coed contest, and teas sponsored by the Associated Women Students to honor San Francisco high school seniors. And of course there were numerous dances, such as this sophomore formal advertised in the November 24, 1937, *Guardsman* left. The very first formal dance (white ties and formals required) was held at the Mark Hopkins Hotel. In spite of Cloud's encouragement, only a small number of students participated in such activities, because there was no core group of students living on campus. In this *c.* 1950s photograph below, young women pose in their fancy dresses for an unidentified occasion.

In 1954, Lee Meriwether, above, was a drama major at CCSF until her studies were interrupted when she won the Miss San Francisco beauty pageant. The first city resident to do so, the mayor and board of supervisors issued her a congratulatory resolution. After winning the Miss California title in Santa Cruz, she went on to be crowned Miss America. She has starred in *All My Children*, numerous movies, including the original *Batman*, and costarred in the CBS series *Barnaby Jones*. In the past, she has lent her support in the Balboa Reservoir campaigns, and as seen below, returned to perform in the campus production of *Long Day's Journey into Night* with Dirk Alphin in 2008. Other former CCSF students who have gone on to successful acting careers include Bill Bixby, Danny Glover, and Barbara Eden. (Below, courtesy of Ian Birchall.)

In May 1946, the college sponsored its first Mardi Gras event with dancing and games. By 1950, the event had grown into a citywide fete, with a parade, marching bands, floats, and decorated cars proceeding up Ocean Avenue to the college. JoAnn Perron and Robin Rosenfield, pictured here in May 1950, were that year's king and queen of the parade. (SFPL.)

By the 1970s, students used the Ram Plaza, in front of Smith Hall, to socialize. It also became the location for celebration of Black Panther Day by the Black Students Association. This event was in tune with the insistence by the association that the college meet the long ignored academic needs of African American students by instituting an African American curriculum and offering an associate in arts degree in African American Studies. (Courtesy of Antonio Ragadio.)

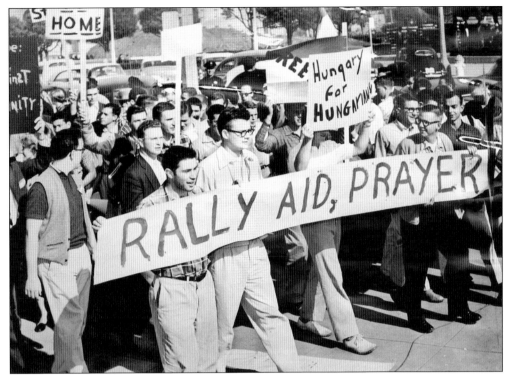

In addition to enjoying formal dances and club activities, some students became involved in various rallies. They listened to political positions of mayoral candidates, publicized their campaign to gather funds to send their basketball team to Kansas to participate in the National Junior College championships, or, as seen here, demonstrated at City Hall in protest of the Russian invasion of Hungary in 1956. (SFPL.)

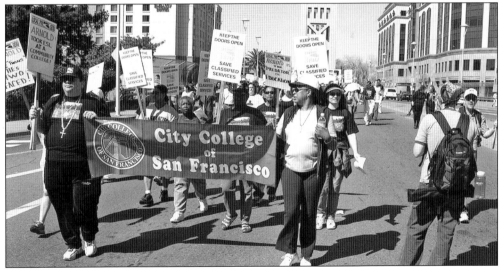

In March 2004, college faculty members, administrators, trustees, and staff traveled to Sacramento to protest budget cuts. Above, the college contingency marches down Capitol Mall. City College has participated in many such protests as well as in municipal parades and celebrations. (Courtesy of Steve Kech.)

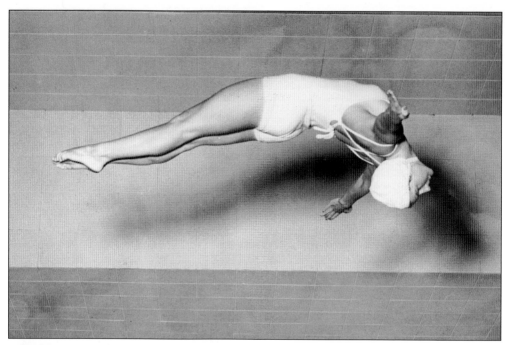

CCSF diver Helen Crlenkovich, above, was one of the most successful athletes in the world on the 3-meter springboard and 10-meter platform, winning championships in 1939, 1941, 1943, and 1945. More than any other female diver in history, she came closest to meeting the men's standard of excellence. Although chosen to represent the United States in the 1940 and 1944 Olympic Games, the games were cancelled. She made her professional debut in San Antonio as the star of an "aquatic ballet," *Rhapsody in Swimtime*, and later became a Hollywood stunt double, performing most of the springboard dives for Esther Williams and doubling for Jane Russell in *Jungle Jim*. In 2008, she received posthumous recognition by the World Acrobatic Congress for her life achievements in swimming and diving. Crlenkovich, left, was the only woman in the 1939 aeronautics course. (Courtesy of Bari Miller.)

Football has always played an important role at CCSF. Only two months after the college opened, the Rams played Modesto, as seen by the October 25, 1935, souvenir program right. During the 1948–1949 academic year, CCSF had one of their greatest gridiron teams. Coached by Grover Klemmer, they played an undefeated season, with 12 wins and no losses, and winning the Northern California Junior College Conference title. Then they participated in the postseason State Gold Dust Bowl, where they won a decisive victory over Chaffey Junior College by a score of 20 to 7. That 1948 squad is pictured below. This team produced many great Division I and professional players, including Ollie Matson, Burl Toler, and Walt Jourdan.

Souvenir Program

MODESTO
vs
San Francisco J C

October 25, 1935
8 P.M.

Distributed by
ASSOCIATED STUDENTS M J C

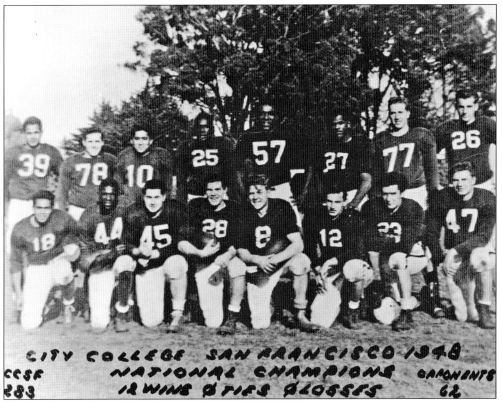

Members of the 1948 team gather for the Rams opening game of the 2008 season. From left to right are (first row) Don Morretini, Burl Toler, Bob Toquinto; (second row) Don Stillwell, Roy Giorgi, Edgar West, Bob Clark, Walt Jourdan, Ken White, Bill Koenig, Rudy Smith, and CCSF interim chancellor Dr. Don Q. Griffin. Until the war, the Associated Students used a live ram at athletic events. Then in 1947 fraternity officers persuaded Armour, Swift, and Company to temporarily loan them a ram for college events. It disappeared, and the fraternity was billed $23. During the 1953–1954 academic year, student leadership and several fraternities purchased "Sammy," the Merino ram pictured left. He roamed freely on the fenced West Campus, once wandering into an archery practice range. Fortunately, the students were poor shots. (Above, Davey; left, SFPL.)

Mayor Newsom declared November 7, 2009, as Burl A. Toler Day. At half time during the Rams versus Foothill game, the college inducted Toler, right, into its new "wall of fame" on Cloud Circle. Toler transferred from CCSF to the University of San Francisco, playing linebacker for the Dons and graduating in 1952. A knee injury sidelined his career with the Cleveland Browns, and instead he became the first African American to serve as an NFL official, from 1965 to 1989. He then spent 17 years at Benjamin Franklin Middle School as a teacher and later the San Francisco Unified School District's first African American principal. The Rams won that November 2009 game 46 to 33, and they continue to excel. Below, in City Hall, head coach George Rush holds a proclamation given to him by Lawrence Wong, trustee, for their winning 2003 season. (Davey.)

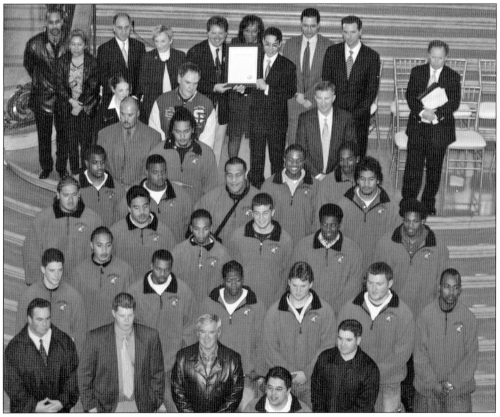

Faculty, staff, administration, and board members—all at one time CCSF students—pose before Science Hall in 2005. From the very beginning, former students sought employment at the college, including Ralph Hillsman, captain of the first basketball team, who started out as the basketball coach but became dean of men; Don Jensen was the Associated Student's president and became a

counselor and psychology instructor; and Lawrence Wong, a graduate of the newly organized hotel and restaurant program, returned as an instructor in 1939. Wong, the first instructor of color at the college, served as chair of the department from 1951 until he retired in 1982. By 1968, there were 40 former students employed at the college. The number continues to grow. (Davey.)

PRESIDENTS AND CHANCELLORS

Archibald J. Cloud — President 1935–1949
Louis G. Conlan — President 1949–1970
Lloyd D. Luckman — Acting President 1967
Louis F. Batmale — President 1970
Harry Buttimer — President 1970–1974
Harry Frustuck — Interim president 1974–1975
Kenneth S. Washington — President 1975–1982
Warren R. White — Interim President 1982–1983
Carlos B. Ramirez — President 1983–1988
Willis F. Kirk — President 1988–1990
Jacquelyn W. Green — President 1990–1991

James Dierke — President, Centers Division, 1970–1974
Carolyn Biesadecki — Acting President, Centers Division, 1974–1975
Calvin Dellefield — President, Centers Division, 1975–1978
Laurent Broussal — President, Centers Division, 1978–1984
Nancy Swadesh — President, Centers Division, 1984–1986
Rena Bancroft — President, Centers Division, 1986–1991

Louis G. Conlan — Chancellor 1970
Louis F. Batmale — Chancellor 1970–1977
Herbert M. Sussman — Chancellor 1977–1982
Hilary K. Hsu — Chancellor 1982–1990
Evan S. Dobelle — Chancellor 1990–1995
Del M. Anderson — Chancellor 1995–1998
Philip R. Day Jr. — Chancellor 1998–2008
Don Q. Griffin — Chancellor 2008–present

I cannot live without books.

—Thomas Jefferson to John Adams, 1815

This book is dedicated to the memory of Austin White (March 25, 1932–August 24, 2008), who attended City College before transferring to San Francisco State University. He received his M.A. from the University of California, Berkeley and had full-time postgraduate fellowships in history at Columbia and Stanford Universities. After teaching at Balboa High School, where he created its honors program in history and English, he joined the faculty at City College in 1968. Besides being a professor of history, he served in several administrative positions: chair of the Social Sciences Department; founder and president of the Department Chairpersons Council; vice chancellor for Planning, Research, and Development; and executive vice chancellor. He also served many terms on the Executive Council of the Academic Senate and on other college committees. (Courtesy Sandra Reid.)

www.arcadiapublishing.com

MAP SEARCH

Discover books about the town where you grew up, the cities where your friends and families live, the town where your parents met, or even that retirement spot you've been dreaming about. Our Web site provides history lovers with exclusive deals, advanced notification about new titles, e-mail alerts of author events, and much more.

MADE IN THE USA

Arcadia Publishing, the leading local history publisher in the United States, is committed to making history accessible and meaningful through publishing books that celebrate and preserve the heritage of America's people and places. Consistent with our mission to preserve history on a local level, this book was printed in South Carolina on American-made paper and manufactured entirely in the United States.

This book carries the accredited Forest Stewardship Council (FSC) label and is printed on 100 percent FSC-certified paper. Products carrying the FSC label are independently certified to assure consumers that they come from forests that are managed to meet the social, economic, and ecological needs of present and future generations.

FSC
Mixed Sources
Product group from well-managed forests and other controlled sources

Cert no. SW-COC-001530
www.fsc.org
© 1996 Forest Stewardship Council

Find Your Place in History.